SOMERS LIBRARY

D1170725

D1170725

JUN 10 '

RODGERS LIBRARY

ART NOUVEAU

SPIRIT OF THE BELLE EPOQUE

SUSAN A. STERNAU

NEW LINE BOOKS

Copyright © MMVI by New Line Books Limited
All rights reserved.

No part of this publication may be reproduced, stored in a
retrieval system or transmitted in any form by any means
electronic, mechanical, photocopying or otherwise, without
first obtaining written permission of the copyright holder.

Fax: (888) 719-7723
e-mail: info@newlinebooks.com

Printed and bound in Singapore

ISBN 1-59764-076-X

Visit us on the web!
www.newlinebooks.com

Author: Susan A. Sternau

Publisher: Robert M. Tod
Editorial Director: Elizabeth Loonan
Book Designer: Mark Weinberg
Production Coordinator: Heather Weigel
Senior Editor: Edward Douglas
Project Editor: Cynthia Sternau
Assistant Editors: Terri Hardin *and* Shawna Kimber
Picture Reseacher: Laura Wyss
Desktop Associate: Michael Walther
Typesetting: Command-O, NYC

Picture Credits

Art Resource, New York 98
Anderson Collection of Art Nouveau, University of East Anglia 64-65
The British Museum, London 29, 58
The Cleveland Museum of Art, Ohio 96
The Detroit Institute of Arts, Michigan 39
Fog Art Museum, Cambridge, Massachusetts 18, 21
Foto Marburg—Art Resource, New York 26
The Free Library, Philadelphia 93
Galleria d'Arte Moderna, Venice—Art Resource, New York 122
The Guggenheim Museum, New York 118
Korab, Balthazar 55
Historiches Museum der Stadt Wien, Vienna—Art Resource, New York 103
Kunsthalle Bremen—Art Resource, New York 79
Kunsthistoriches Museum, Vienna—Art Resource, New York 104-105
Lessing, Erich—Art Resource, New York 19
The Louvre, Paris 24-25
Mackintosh Collection, Glasgow University 99, 100-101, 117
The Metropolitan Museum of Art, New York 37, 53, 68, 71, 113, 124
Modemuseum in the Münchner Stadtmuseum, Munich 28
The Munch Museum, Oslo—Art Resource, New York 80
Musée des Arts Decoratifs, Paris—Art Resource, New York 52, 69, 83, 84, 97
Musée des Beaux Art, Ghent 86
Musée des Beaux Arts, Nancy 51
Musée de l'Ecole, Nancy 66, 67
Musée Gustave Moreau, Paris 36
Musée Horta, Brussels 17, 31, 34
Musée d'Orsay, Paris—Art Resource, New York 75, 91, 112
Musée Rodin, Paris 88-89
Musée Toulouse-Lautrec, Albi—Giraudon/Art Resource, New York 85
Museo Stibbert, Florence—Art Resource, New York 62
Museum am Ostwell, Dortmund—Art Resource, New York 59
The Museum of Fine Arts, Budapest 30
The Museum of Modern Art, New York 23, 32-33, 47, 48, 49, 63, 72-73, 90, 94, 95, 106, 107, 108, 109, 114, 116, 123
Nasjonalgalleriet, Oslo—Art Resource, New York 81, 92
The National Gallery of Art, Washington, D.C. 11
The New York Public Library 15, 27, 43, 46, 60
Österreische Galerie, Vienna—New York, Art Resource 6-7, 120-121
The Pierpont Morgan Library—Art Resource, New York 42, 44, 56-57, 59
The Phillips Collection, Washington, D.C. 115
Private Collection—Art Resource, New York 40, 54, 70, 74
Rijksmuseum Kröller-Müller, Otterlo 77
Städtische Galerie im Lenbachaus, Munich 119
The Smithsonian Institution, Washington, D.C.—Art Resource, New York 4, 38
Stapleton Collection, Great Britain—Art Resource, New York 61
The Tate Gallery, London—Art Resource, New York 8-9, 20, 35
Vanni, Gian Berto—Art Resource, New York 110, 111, 124, 125
Victoria and Albert Museum, London—Art Resource, New York 12-13, 14, 45

CONTENTS

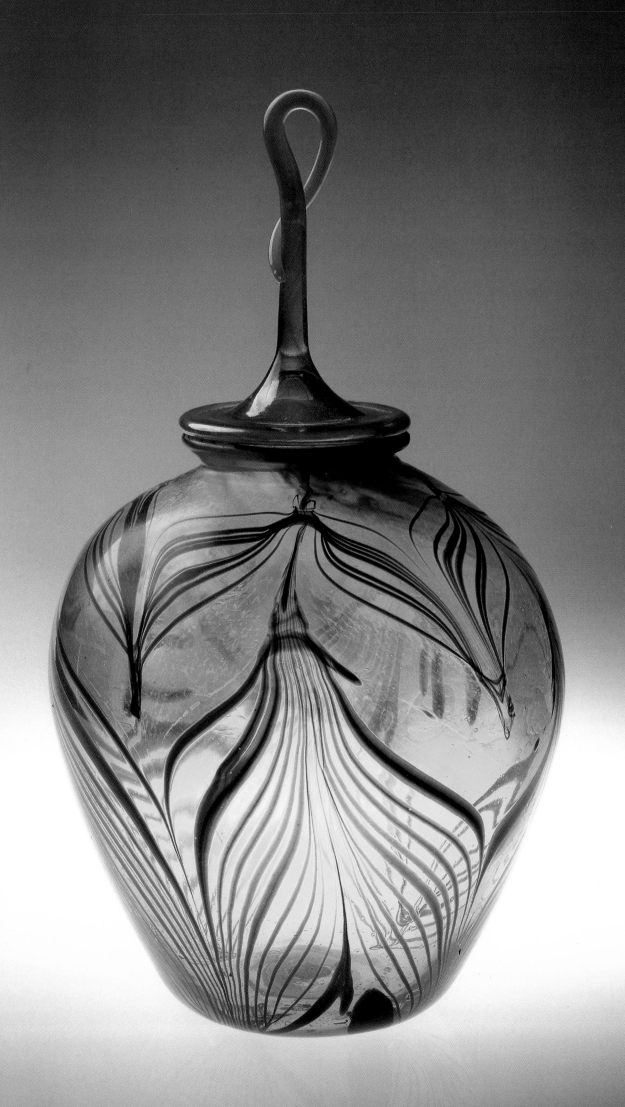

INTRODUCTION

"Art Nouveau" defines the elegant, unified style that flourished from the early 1880s to the beginning of World War I. It was the beginning of a century of great change, at a moment when other great changes, such as the Industrial Revolution and the machine age were already in full swing. It was an amazing time, and for the many artists and designers who created Art Nouveau it was a symbolic moment—the end of a century of change—and the beginning of another one.

Characterized by ornamental, sinuous lines, Art Nouveau was a highly original style based on the natural forms of flora and fauna. The unique work and fine craftsmanship of individual artists were the hallmarks of this style, which provided a transition between the overwrought abundance of Victorian "historicism" and the sleek functionality of Modernism.

At its height around 1900, Art Nouveau was broadly popular in both continental Europe and in the United States. As a style, it brought together the fine arts, the applied arts, architecture, and decoration of all types. The style was at its best in the work of such diverse artists and craftsmen as Aubrey Beardsley, Louis Comfort Tiffany, Pierre Bonnard, Edouard Vuillard, Henri de Toulouse-Lautrec, Paul Gauguin, René Lalique, Emile Gallé, Gustav Klimt, and Edvard Munch. It was similarly spectacular in the architecture of Victor Horta, Hector Guimard, Louis Sullivan, Charles Rennie Mackintosh, and Antonio Gaudí.

Because Art Nouveau was such a broad movement, it has been open to conflicting interpretations. Some scholars have denied the existence of Art Nouveau in architecture. Others claim that there was truly no Art-Nouveau painting, as all the painters of the period were really part of other movements or styles. Some have said the movement centered in England, while others have maintained it was primarily French. The contributions of the United States and Spain are simultaneously celebrated and minimized.

Some have praised the Art-Nouveau movement for its clarity of vision, and others have criticized it for tasteless exaggeration and for creating interiors and furniture that were difficult to live with. And still others have convincingly credited Art Nouveau with the beginnings of the Modern style in architecture, and with many of the major modern movements in painting as well—Cubism, Fauvism, Expressionism, and Abstraction, to name the most far-reaching.

The Art-Nouveau style contains within it many apparent contradictions. It was an art which stressed its newness, yet it also drew major inspiration from Oriental art, the traditions of which were far older than Western civilization, and from ancient Celtic art as well. It was considered an "anti-historical" movement, yet some of its major innovators were influenced by the English Arts and Crafts movement, which drew its inspiration mainly from the medieval and Early Renaissance periods. In France, the movement was strongly influenced by neo-Gothic and neo-Rococo styles. It was an art of the

Vase

Louis Comfort Tiffany, 1894; glass. The Smithsonian Institution, Washington, D.C.
Tiffany was an ardent admirer and collector of antique glassware, particularly
that of ancient Rome. He also traveled to Spain, North Africa, and Egypt
in the course of exploring the colors used in the art of the Islamic world.

curving, sinuous line on the one hand, but a significant contribution to Art Nouveau was made by artists working with an idiom of rectilinear form—notably the Glasgow School in Scotland, and through their influence, many Austrian artists of the Secession style as well.

It can be argued that any movement as broad in scope geographically would be bound to have variations and contradictions. It is likely that the very richness of the Art-Nouveau movement was enhanced by many forces that coalesced into what was, in its day, a powerful, far-reaching, and extremely popular style.

When Art Nouveau fell out of fashion in the 1920s and 1930s, it was replaced by the clean, simple geometries of Art Deco. The extravagant curves of Art Nouveau were seen as old-fashioned and viewed with contempt. Many Art-Nouveau products were put away, spurned, or destroyed. Rooms once decorated in what had been the height of fashion were redecorated to conform to the latest taste. In Belgium and elsewhere, some Art-Nouveau buildings were demolished to make way for the "new," with little thought to the fact that Art Nouveau might have contributed to the birth of the Modern movement.

It was not until nearly half a century later, in 1952, that the first comprehensive exhibition devoted to Art Nouveau was organized in Zurich, Switzerland. Present-day interest in Art Nouveau, and in particular its widespread appreciation within the last thirty years, has once again firmly established it as an important art movement.

Portrait of Adele Bloch-Bauer

Gustav Klimt, 1907; oil on canvas; 54 3/8 x 54 3/8 in.
(138 x 138 cm). Österreichische Galerie, Vienna.
Klimt, internationally famous as a portrait painter, successfully combines a naturalistic rendering of faces and hands with his own distinctive vocabulary of geometric abstract ornament (often applied in gold and silver). Note the abstract eye motif in the gown, which the artist borrowed from Egyptian art, in this flattering portrait of a wealthy woman.

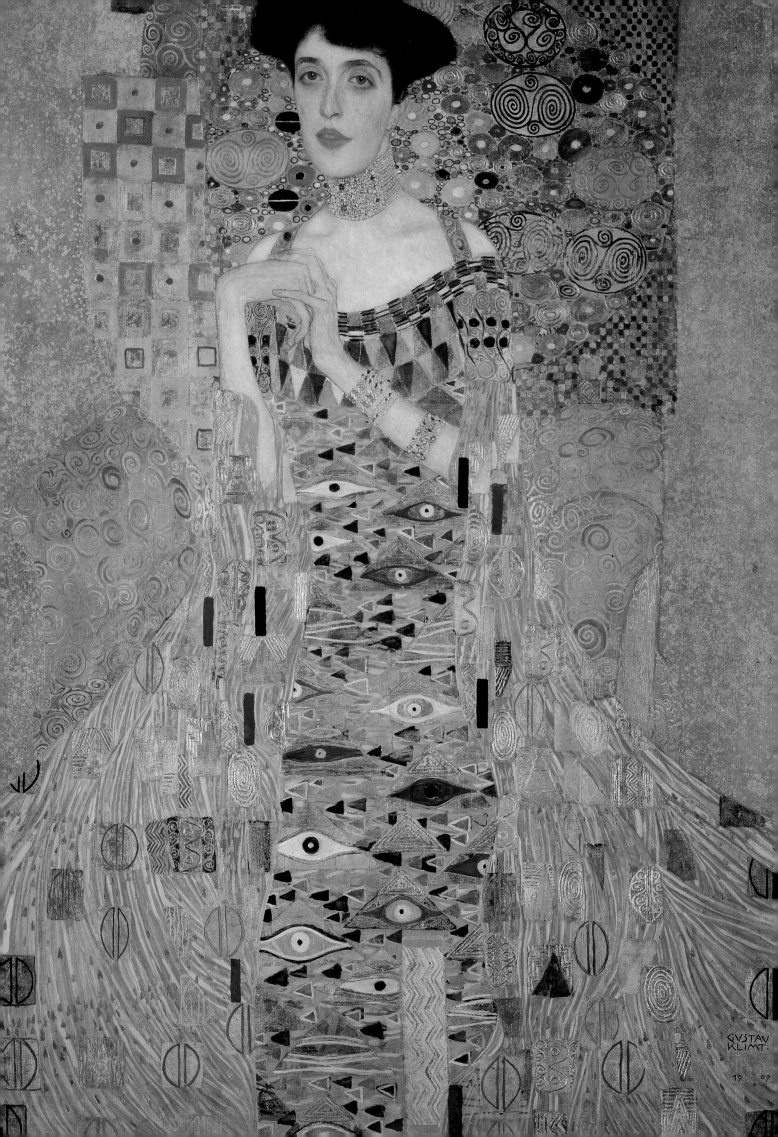

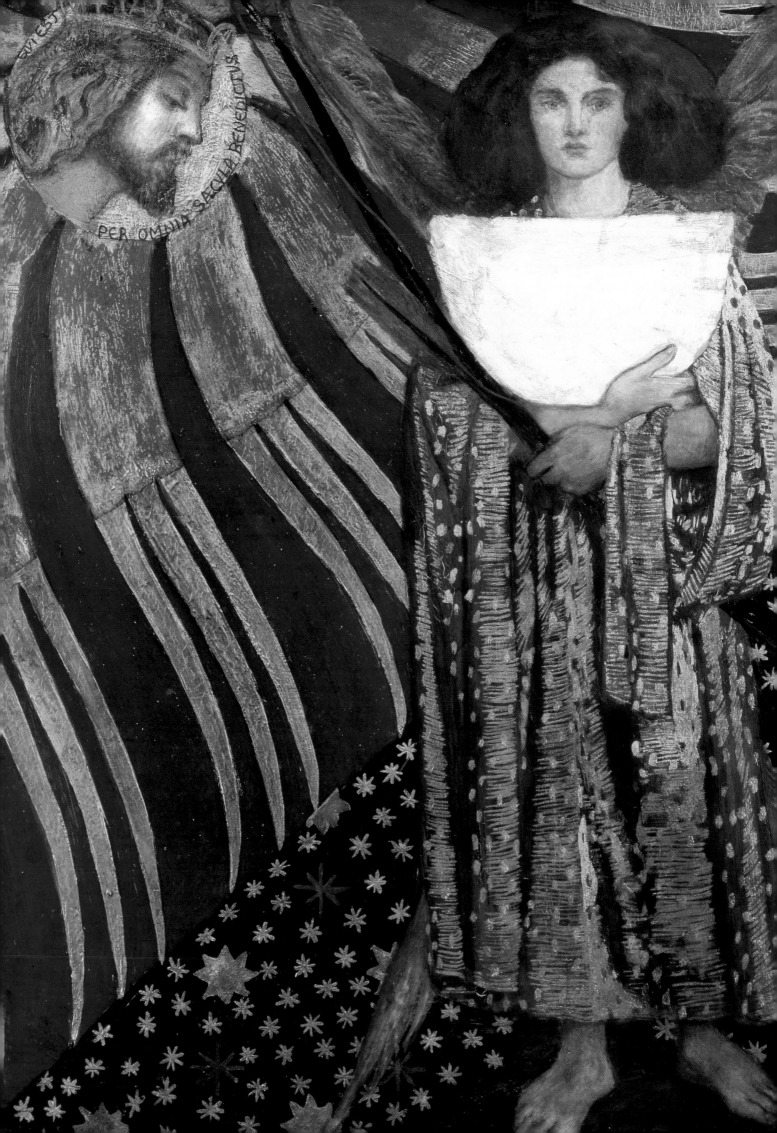

A STYLE IS BORN

Art Nouveau was a style of design, art, and architecture. It was also an art movement with a mission. The name *"l'art nouveau,"* when translated from the French, means, literally, "the new art." It was a movement concerned primarily with newness, with being different from what had come before. Artists and designers from the early 1880s on, in England and France, but also in Belgium, Germany, Scotland, Austria, Spain, Scandinavia, Italy, and the United States began to look upon the acts of creating, designing, and building in a new way—with freshness and originality.

The Roots of Art Nouveau

The need for a new art arose from a common feeling that the art of the day lacked originality. In England, where Art Nouveau had its roots in the Arts and Crafts movement, artists and designers were reacting against the prevailing Victorian style of "historicism," a style which borrowed art and ornament from many periods of history indiscriminately and combined them into the over-stuffed Victorian parlor. The rise of a powerful middle class—due in part to the Industrial Revolution—had created a demand

Dantis Amor (Dante's Love)

Dante Gabriel Rossetti, 1859; oil on panel;
29 1/2 x 32 in. (75 x 81 cm). Tate Gallery, London.
The work of this English Pre-Raphaelite painter was a
source of inspiration to Art-Nouveau artists. In this unfinished
painting, space is replaced by flat pattern. Flame-like lines sur-
round the haloed head of Jesus while stars dot the sky around
the central figure, the poet Dante. Beatrice, Dante's great love,
gazes up at him from a "window" made by an encircling moon.

for consumer goods. The age of the machine was able to fill this demand with mass-produced products; yet in both England and France, as well as across the continent, ornament was mass-produced and applied indiscriminately, without regard for the beauty or ugliness of what resulted. Every period of history was mined to fill the growing demand and taste for ornament, and the consequent decline in originality was sudden and dramatic.

Other aspects of nineteenth-century style against which Art Nouveau reacted were both the form and content of official "Salon" painting. This academic style (against which the French Impressionists were already rebelling) was based on an imitation of life, filtered through an aesthetic which favored the classical forms of Greece and Rome. The subject matter was realistic and narrative, and works were based on events of history, mythology, or everyday life (this last is known as "genre painting"). Artists sought to recreate those events in space for the viewer as realistically and dramatically as possible, and, to this effect, easel painting and sculpture were considered the only "fine art" means of expression.

In contrast, Art Nouveau as both a style and movement sought a unity of expression in all forms of art and design. Design of fabric and wallpaper was held equal to the design of a lamp, bookbinding, teapot, cutlery, chair, vase, necklace, poster, or building of any purpose. Art Nouveau was not only a new style—it was a new world view that sought a synthesis of all the arts, and valued the craftsman and architect as highly as the painter or sculptor.

William Blake

William Blake (1757–1827), the visionary English painter, poet, and illustrator, had been a precursor to Art Nouveau and exerted a major influence on the style's development. His work, which had fallen out of fashion, was reintroduced by the Pre-Raphaelite painter Dante Gabriel Rossetti (1828–82) to his friends and colleagues. Blake's paintings and illustrations have the quality of imaginative, often exagger-

ated, visions. His linear rhythms, asymmetry, and curving, often flame-like lines anticipated the style of Art Nouveau. In Blake's watercolor, *The Whirlwind of Lovers: Paolo and Francesca* (c. 1824–26), the figures are subservient to the swirling, flame-like patterns within which Blake has enclosed them. Here Blake recreated his own version of the story of two doomed adulterous lovers, Paolo and Francesca, who were murdered by Francesca's husband (Paolo's brother) when he caught them together in the act of love. The tale is recounted in the *Inferno* section of *The Divine Comedy* by the great Italian poet, Dante Alighieri.

Blake's interest in the interrelationship of typography to ornament on the page, developed from an observation of medieval illuminated manuscripts, was a factor in his style which was of great interest to the pioneers of Art Nouveau.

The Great Red Dragon and the Woman Clothed with the Sun (c. 1805–10) was an illustration for the Book of Revelations that Blake executed for his long-term patron, Thomas Butts. The dragon is a demonic creature with immense bat's wings, a thickly coiled tail, human limbs, and flame-like coloring. A golden angel with a halo of flaming hair represents the "spirit"; she has risen up to confront the beast and attempts to protect the tiny human creatures at her feet from the deluge he creates. The flattened, decoratively patterned drapery of Blake's angel would occur again and again in Art Nouveau.

The Great Red Dragon and the Woman Clothed with the Sun

William Blake, 1805–10; watercolor; 13 3/4 x 12 3/4 in. (34.9 x 32.9 cm).
Rosenwald Collection, The National Gallery of Art, Washington, D.C.
This is an illustration for the Bible's Book of Revelations done for Blake's long-term patron, Thomas Butts. The Red Dragon is a bat-winged demon with the coiled tail of a serpent and human limbs. The kneeling angel represents the Spirit, who rises up to confront the beast and protect the people at her feet from his deluge.

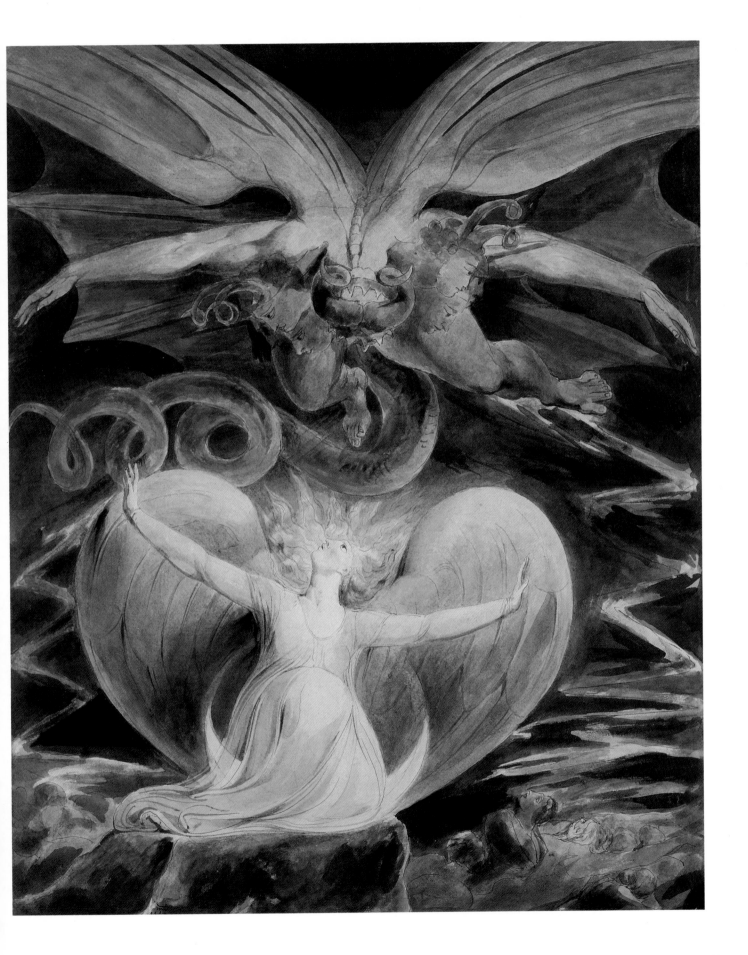

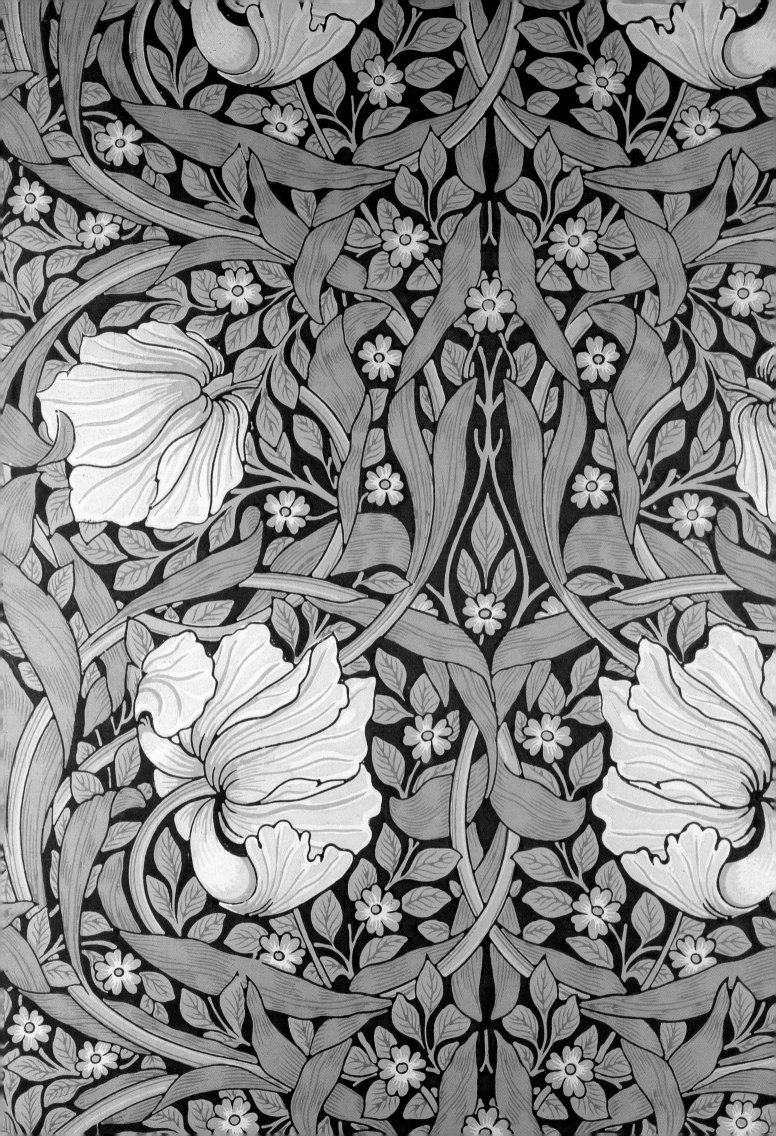

William Morris

At the heart of the desire for aesthetic synthesis, which governed the principles of the new art, was William Morris (1834–96), an English craftsman, painter, poet, and socialist who had been educated at Oxford where he met his lifelong friend, the painter Sir Edward Burne-Jones (1833–98). Together, they discovered the writings and philosophy of art historian John Ruskin, who expressed the belief that true art was an expression of man's pleasure in his work, and that the arts, when honest, were at once beautiful and useful. Ruskin upheld the medieval period as an ideal, saying that the splendid quality of medieval craftsmanship derived from the craftsman's pleasure in his work. With Ruskin, Morris came to believe in the destructive effects of the Industrial Revolution and the evils of the machine age.

Morris early on developed an enduring love for the buildings and art of the middle ages, for he had the inclinations of a craftsman and was always happiest using his hands. He began his career apprenticed to an architect, but in his spare time he wrote, modeled clay, sculpted wood and stone, illuminated manuscripts, and embroidered. In 1861, Morris started a firm of decorators, Morris & Company, which sought to return to the craftsmanship and splendor of the middle ages, and produced wallpaper, textiles, stained glass, tapestries, and furniture. His final venture was the influential Kelmscott Press (founded 1890), where he designed type, bindings, and page borders.

Additionally, Morris's enthusiasm for crafts led to the formation of craft guilds that also celebrated individual workmanship and the historic styles of the middle ages and the early Renaissance. William Morris was joined in his call for a unity of art and life by, among others, Arthur Heygate Mackmurdo (1851–1942), who founded the Century Guild in 1880–81, and Walter Crane (1845–1915), the illustrator and writer who co-founded the Arts and Crafts Exhibition Society in 1888. This force in England, which sought reforms and unification of all arts and crafts came to be known collectively as the Arts and Crafts movement. Its products were widely spread throughout continental Europe and the United States and its style was one of several that formed the basis for Art Nouveau.

In his choice floral motifs, as well as in the rhythms of his designs, Morris set the stage for Art-Nouveau style. Morris's designs, such as his *Pimpernel* wallpaper of 1876—filled with a twining profusion of vines and flowers—originated from nature. Morris was a master of pattern and rich design; his work was often intricate, unified by the twisting, undulating movement of flowers and their stems. But these flowers were still fairly naturalistic and proportional—they did not have the stylized qualities that natural forms were to assume with full-fledged Art Nouveau.

Pimpernel Wallpaper

William Morris, 1876. Victoria and Albert Museum, London.

Mastery of pattern is apparent in the intricate floral design by this leader of the English Arts and Crafts movement, whose work and philosophy provided inspiration to Art Nouveau. Morris himself found inspiration in the fine craftsmanship of the middle ages, and he became famous for his designs for wallpaper, fabrics, stained glass, tapestries, and furniture, as well as his printing press, the Kelmscott Press.

Pattern and Style

Morris formed his ideas about design in an era that was already expressing interest in change. In 1856, Owen Jones (1809–74), an industrial designer, architect, and interior designer, published *The Grammar of Ornament*, which had an enormous influence on taste. Owen Jones called for ornament to be based on geometry, not naturalism. He put the patterning of lines above perspective and stressed color as a clearly decorative element to be used to differentiate elements in a design. *Horse Chestnut Leaves* (1856), an illustration from Owen Jones' book, demonstrated his interest in flat patterning. Although the leaves depicted were a natural form, they were spread out into a flat pattern; the stress of the design is on geometry, outline, and rhythm, not on creating the illusion of leaves on a tree. Jones was looking at the art of China, India,

Persia, and Egypt, as well as Greek vase painting and medieval Gothic works when he formulated his ideas. This interest in the arts of other cultures, in particular the Far East and Japan, was to become an important aspect in the development of Art Nouveau.

In England, around 1859, books began to appear dealing with every aspect of Japanese life and Japanese art. This sudden interest in Japan was the direct result of a treaty Japan signed with the American, Commodore Perry, in March of 1854, which officially ended the seclusion of Japan. The island of Japan had been closed to foreigners since 1637 and no Japanese citizens had been allowed to leave the country. The only European contact during those years had been a limited trade in porcelain and lacquer with the Netherlands. Japanese art had been so rarely seen in Europe that it was often confused with Chinese art.

Sideboard

Edward William Godwin, c. 1877;
ebonized wood with silver hardware
and imitation leather panels;
height 70 7/8 in. (179.2 cm).
Made by William Watt. Victoria
and Albert Museum, London.
This is an example of Godwin's self-named "Anglo-Japanese" style of furniture. Its box-like forms and clean straight lines are based on Japanese design—which was just becoming known in England through the opening of trade with Japan—and was to become of great importance to the development of Art Nouveau. It is accented by silver pulls and hinges that are both functional and ornamental.

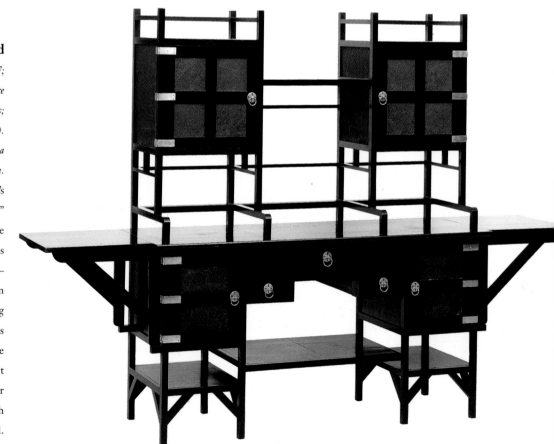

Soon after the signing of the treaty with Perry, French capital began to pour into Japan, enabling the Japanese to build shipyards and iron-foundries. In return, France received imports of Japanese goods. Because the United States, Britain, and Russia were all occupied with wars at this time, they were unable to take advantage of trade opportunities on the same scale as France. Still, Japanese decorative art, wood-block prints, and fine fabrics being sold in Paris shops soon sparked interest in England.

Edward William Godwin (1833–86), an English architect and designer, was one of the first in England to apply what he admired in Japanese style to his own work. The cool elegance and understatement of Japan was evident in the White House, which Godwin built for his friend James Abbott McNeill Whistler in 1877. Godwin also designed furniture which he referred to as "Anglo-Japanese," an example of which was a sideboard (c. 1877) constructed of box-like forms and clean, straight lines that referenced Japanese architecture. Accented by silver pulls and hinges that were both functional and ornamental, the sideboard was refreshingly understated and light in feel—not at all like typical English furniture of the period, which ran the gamut of Gothic, Renaissance, Louis XV, and Baroque styles.

Parallel to the ideas of his contemporary, William Morris, were those of Eugène-Emmanuel Viollet-le-Duc (1814–79), a French architect, writer, and professor who is best remembered for his restorations of medieval buildings. Like Morris, Viollet-le-Duc upheld the idea of unity in the arts and in the decoration of interiors. Furthermore, he foresaw a future of cast-iron architecture, where the material was not concealed by stone but used openly and honestly. Although Viollet-le-Duc's influence declined after the Franco-Prussian War of 1870, his ideas were to have an impact on the future of art and architecture in France, and on the development of Art Nouveau.

Horse Chestnut Leaves

Owen Jones, 1856; book plate from The Grammar of Ornament. *The New York Public Library, Astor, Lenox and Tilden Foundation, New York.* Although the leaves of this design are based in natural form, they are spread out into a flat pattern. The stress of the design is on geometry, outline, and rhythm—not on creating the illusion of leaves on a tree. Jones's book had an enormous influence on the taste of his time, and his interest in the arts of China and Japan were of timely importance to Art Nouveau.

A Style Defined

The intention of Art-Nouveau decoration was to beautify and unify all aspects and objects of everyday life. This was accomplished through flat, stylized decorations which concentrated the eye on the surface ornament and did not attempt to open the window of illusion employed by traditional painting. Equal use was often made of positive and negative space; that is, the spaces and shapes *between* the lines were of equal importance to the lines and shapes themselves.

For an object, design, building, or work of art to be recognized as Art Nouveau, a combination of three elements must be present: first, decorative, curving lines; secondly, specialized motifs; and finally, an emphasis on unity.

The quality of the Art-Nouveau line is the essence of the style: A line that is a living, pulsing, growing force, animating the inanimate and energizing the surface of all it decorates. The lines of Art Nouveau are most often dancing, undulating arabesques, meant to capture the organic energy and life force of plants.

The signature line of Art Nouveau appears in Hermann Obrist's famous *Whiplash Wall Hanging*, an embroidery of 1895. Obrist (1863–1927) was a Swiss sculptor and designer who had studied science and botany before devoting himself to applied art. He founded an embroidery workshop in Florence with Berta Ruchet in 1892, which they then moved to Munich in 1894. Obrist's design shows the whole plant, including its bud, flower, leaves, and root— but it is the exaggerated curves of the stem which make this design so arresting and so Art Nouveau. The piece was originally named "Violets of the Alps," but when a critic compared the frantic movement of the plant's stem to the "violent curves occasioned by the crack of a whip," the name "whiplash" curve was born, and soon became a signature of Art-Nouveau style.

Victor Horta (1861–1947) was an architect who was to be credited with the birth of the Art-Nouveau style in Belgium. The sinuous, undulating lines of the wrought-iron bannisters and columns of his famous Tassel Residence (1892–93) are echoed in every interior aspect of the building, from the linear pattern of the floor tiles, wall decorations, and skylights, to the curving lines of door handles, keyholes, and furniture. Another Belgian, a painter, architect, and designer named Henry van de Velde (1863–1957), created curving, sinuous lines in his work, using flat, simple planes, with strong, simple colors in a style resembling that of the painter Paul Gauguin (1848–1903). Van de Velde was an important proponent of Art Nouveau, both through his design, which was distinctive for the tense energy of its line, and his work as a lecturer, theoretician, and writer. As such, he was one of the most articulate partisans for the new style.

Art-Nouveau Motifs

Art-Nouveau motifs were drawn from a fairly limited range of natural subjects. Most common were the bud (a symbol of new growth and life) and exotic plants with long stems and pale flowers. Lilies and water lilies were particular favorites. Often the stem of the plant was emphasized over the flower because it had more potential to be bent into vibrant curves. Seaweeds were also favored, shown as though still pulled to and fro by ocean currents. Oriental motifs such as chrysanthemums, dragonflies, bamboo, butterflies, irises, and peacocks were popular as well.

Images of women with flowing, billowing, impossibly long hair were also common, and their hair becomes flame-like or resembles ocean waves, depending on the whims of the artist. Women are commonly shown as either creatures of flower-like and delicate virginal beauty, with flowing draperies, transparent veils, and drooping eyelids; or they are *femmes fatales*, evil temptresses with drugged eyes, bared breasts, and seductively flowing hair, ready to seduce, entangle, and destroy those who succumb to their charms.

Staircase in Tassel Residence

Victor Horta, 1892–93. Musée Horta, Brussels.

Horta was an influential and innovative architect credited with the birth of the Art-Nouveau style in Belgium. The sinuous, undulating curves of these wrought-iron bannisters are repeated throughout the building.

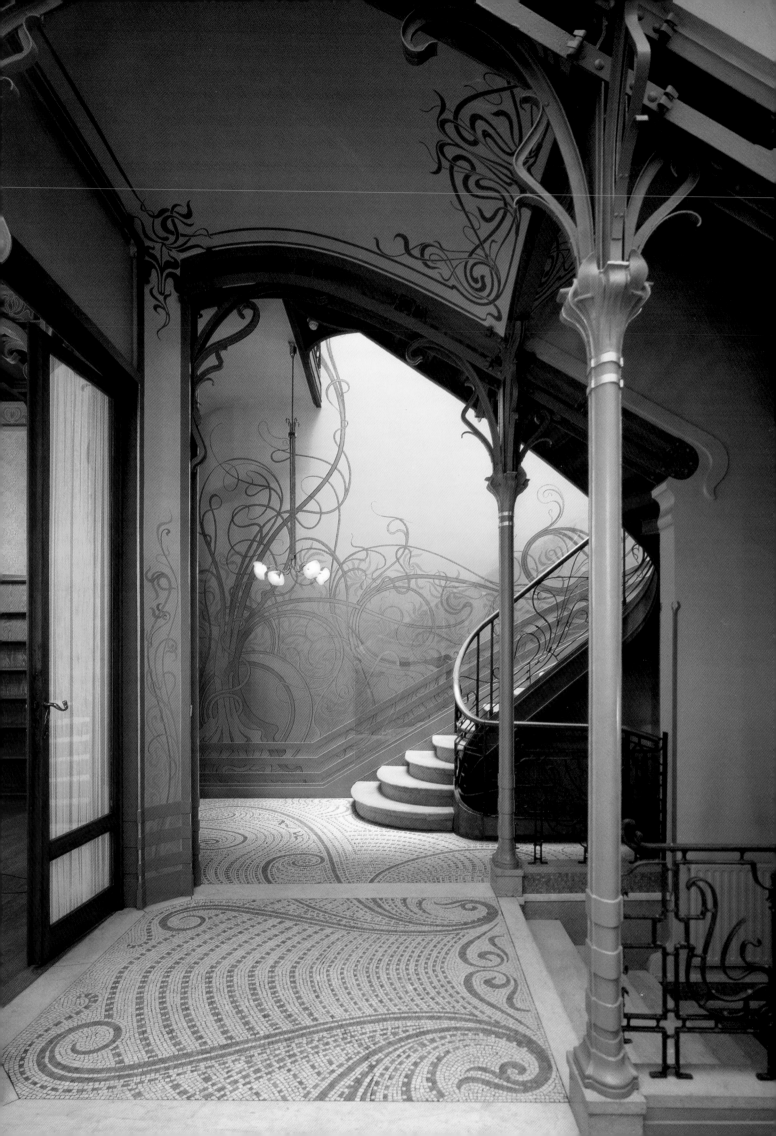

One of Art Nouveau's most memorable seductresses was created by Aubrey Vincent Beardsley (1872–98), a prolific, self-taught English graphic artist and illustrator whose original style was widely imitated. Beardsley's drawing, *Dancer's Reward* —from Oscar Wilde's *Salome* (1894), was done at the peak of his career, before his life was cut short by tuberculosis.

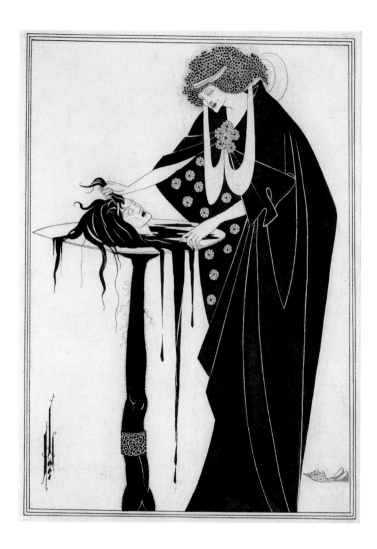

The Dancer's Reward

Aubrey Beardsley, 1894; pen and ink; book plate from Oscar Wilde's Salome;
8 3/4 x 6 1/4 in. (22.2 x 15.9 cm). Bequest of Grenville L. Winthrop,
Fogg Art Museum, Harvard University, Cambridge, Massachusetts.
This grim picture illustrates a climactic moment: the dancer, Salome, receives the reward she has requested for her performance, the head of John the Baptist upon a silver plate. Salome is shown by Beardsley as an evil *femme fatale* or sexual temptress. While this was a popular theme in Art Nouveau, critics nonetheless singled out Beardsley's work as decadent.

It displays the characteristic exaggerated, curving lines, and flat patterning associated with Art Nouveau. Typically, Beardsley gave as much attention to the ornamental qualities of his design as to the grim subject he illustrated—the climatic moment when the dancer, Salome, receives the reward she has requested for her performance—the head of John the Baptist upon a silver plate. This subject, with its decadent overtones, is a prototypical Art-Nouveau depiction of woman as the evil *femme fatale*.

The name "Art Nouveau" was only one of many names given to the style, and this French term, oddly enough, was most commonly used in England. In France, the most common name used was "Modern" style, but it was also called "Métro," or "Guimard's style" after the architect, Hector Guimard (1867–1942) and the Métropolitan (subway) entrances of his design. In Belgium, the style was called "Horta's Style," after the architect Victor Horta. Mocking names were also commonly used: "Noodle," "Eel," "Tapeworm," and "Yachting" style were among the most frequent. In Italy, Art Nouveau was called "Floral" style (referring to the abundance of floral motifs) or "Liberty" style (after the famous London department store). In Germany, it was called *Jugendstil* ("Youth" style), after the periodical *Jugend*. In Austria, the term "Secession" style was used, in reference to the Vienna Secession Movement.

Art-Nouveau decoration was by nature versatile. At the height of the style's popularity, it was used to decorate and beautify almost every conceivable handmade and manufactured object, as well as the interiors and exteriors of many shops, restaurants, and private homes. Because of changing customs, women had more freedom to frequent tea shops, restaurants, and shops. The owners of these establishments were eager to redecorate in the fashionable Art-Nouveau manner because it was thought to appeal to women's tastes. The appearance of large department stores in cities also meant that, in order to remain in business, smaller establishments had to strive to be attractive, and a unique Art-Nouveau decor often enabled a small business to stand out from the anonymity of the larger stores.

The Houses of the "New Art"

The actual name, Art Nouveau, which was eventually accepted in most countries, was coined when S. Bing opened a shop called Maison de l'Art Nouveau ("the house of new art") at 22 rue de Provence in Paris. A native of Hamburg, Germany, Bing was a dealer and connoisseur of Japanese art. He invariably used the initial S. instead of his given name, which he may have changed from Sigfried to Samuel to avoid anti-German sentiments in France (only to encounter equally strong anti-Semitic ones). Bing was a great admirer of Art-Nouveau artists and did much to promote them and their work. In his opening show of December, 1895, Bing presented the work of many artists whose names have become synonymous with Art Nouveau. He commissioned French painters Pierre Bonnard, Edouard Vuillard, and Henri de Toulouse-Lautrec, among others, to make designs for stained glass executed by the American glassmaker, Louis Comfort Tiffany. The show also presented glass designed by Emile Gallé, jewelry by René Lalique, and posters by Aubrey Beardsley, William Bradley, and Charles Rennie Mackintosh, among others. Sculpture by Auguste Rodin and paintings by many artists were also included.

Bing was also responsible, in later shows, for introducing Paris to interior designs by Henry van de Velde and paintings by Edvard Munch. After 1902, Bing retired and his shop became once again a gallery of Far Eastern art and antiquities, signaling the decline in popularity of the style. However, Bing made an undeniable contribution to Art Nouveau; he gave it a name and a place to be seen.

In England, Liberty's was the most important Art-Nouveau store. In 1875, Arthur L. Liberty opened his store, selling Oriental goods such as Japanese silks in London. After he returned from a trip to Japan in 1889, he opened a branch of Liberty's in Paris and began selling a new line of fabrics in the Art-Nouveau style. Liberty's fabrics were seen everywhere and became a status symbol of the Modern style. Art historian Mario Amaya considers that Liberty fabrics "did more to spread the message of Art-Nouveau curvilinear design than almost anything else produced at the time."

Arthur Silver was another designer of Liberty fabrics whose studio produced fabrics in cheaper materials more affordable by the middle and lower classes. Thus Art Nouveau, which was often used in the production of luxury objects and furnishings, was also available to a wider public. Silver's patterns took full advantage of the undulating, wave-like qualities of Art-Nouveau line to create fabrics at once elegant and decorative.

Also contributing to the popularity of Art Nouveau and the quick spread of visual ideas and information were the many periodicals of the time that celebrated the style. Throughout the 1880s and 1890s, *The Studio*, *The Dial*, *The Hobby Horse*, and *The Yellow Book* in England, *Jugend* (Youth), *Pan*, and *Simplicissimus* in Germany, *Ver Sacrum* in Austria, *La Plume* (The Pen), *L'Art Décoratif*, and *La Revue Blanche* (The White Revue) in Paris, *L'Art Moderne*

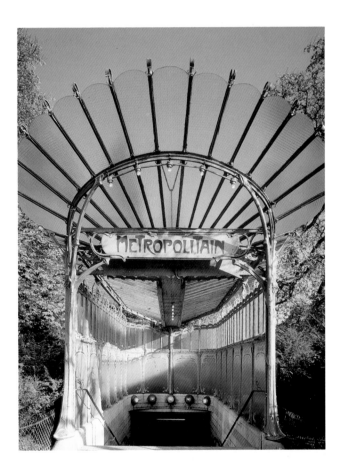

Entrance to Paris Métro: Port Dauphine Station

Hector Guimard, c. 1900; cast iron painted green, amber glass fixtures. Paris. Guimard's innovative entrances for the Paris subway system are still landmarks in that city. The street lights that frame the entrances resemble large exotic plants or flowers, an illusion which is enhanced by the green paint decorating the wrought iron and glass structures.

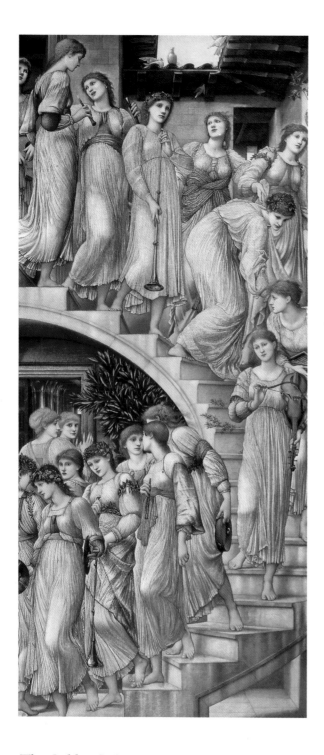

The Golden Stairs

Sir Edward Burne-Jones, 1880; oil on canvas;

109 x 46 in. (276 x 117 cm). Tate Gallery, London.

A procession of beautiful maidens in long robes seem to
float, rather than walk, down a curving staircase. These
angelic beings carry musical instruments as they descend. Some
of their heads are crowned with laurel leaves, which accent their
flowing hair—a style which Burne-Jones helped to popularize.

in Belgium, and *The Chap Book* and *The Craftsman* in the
United States, among others, spread the word about the new
style. Such periodicals, being easily sent or carried, brought
Art Nouveau almost effortlessly across oceans and conti-
nents, and they carried with them the enthusiasm of the
artists and craftspeople working in the new style.

The Formative Years

James Abbott McNeill Whistler (1834–1903) was an
American expatriate painter who studied art in Paris, and
came to settle in London in the 1850s. Whistler was an
enthusiastic collector of Japanese prints, to which he had
been introduced in France by his Impressionist friends. He
did much to promote his enthusiasm for things Japanese, first
by including the kimonos, fans, china, screens, and prints he
purchased in his paintings, and then by adapting the actual
style characteristics of the Japanese art he so admired.

Some of the most outstanding aspects of Japanese style
found their way into Art Nouveau via Whistler and the
French Impressionists of the 1870s and 1880s. Of interest
was the two-dimensional picture surface—not the typical
three-dimensional picture surface of Western art which
strives to create the illusion of space. Bringing the picture
plane to the surface allowed the artist to place figures freely
in space. The absence of a central perspective also increased
this freedom. Other aspects of Japanese style were a high
horizon line; human figures made taller (and thus more ele-
gant); and the use of vertical lettering on the picture surface
so that text and picture became one visual whole.

Whistler's *Nocturne in Black and Gold: The Falling Rocket*
(c. 1875) was called by critic, John Ruskin "a pot of paint
flung in the public's face." (Whistler subsequently sued
Ruskin for libel in connection with this remark.) The musi-
cal title is common for Whistler—he often called his paint-
ings nocturnes, symphonies, or harmonies—and his color
combinations anticipated those popular in Art Nouveau:
yellow and white, yellow and violet, blue and green.
Whistler's interest in painting as an approximation of music
was an idea of the times that filtered down to Art Nouveau
as part of a general unity of arts. Whistler began his career
as an Impressionist painter, that is, he was interested in cap-
turing the fleeting effects of light with freely applied paint
strokes. Indeed, *Nocturne in Black and Gold* anticipates twen-
tieth-century Abstraction in its freedom.

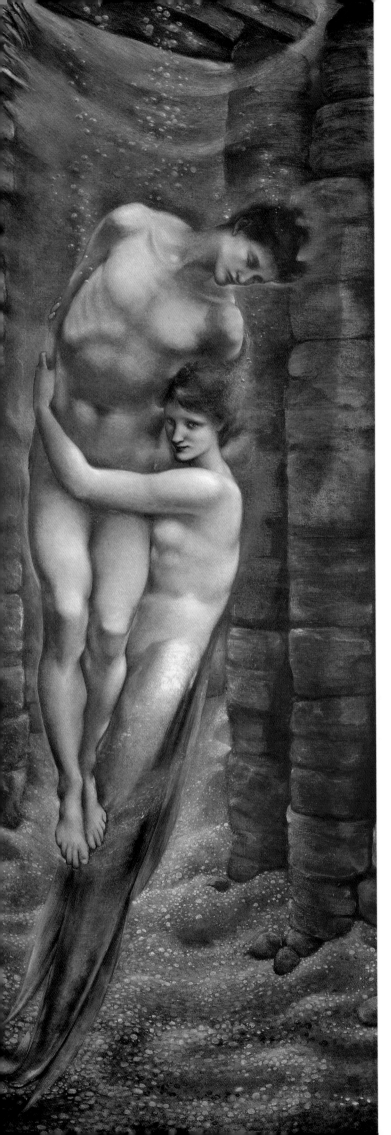

The Peacock Room (1876–77) was a more obvious example of Whistler's fascination with Japanese art. He chose the peacock, the Oriental symbol of longevity, as a motif to harmonize with his painting *The Princess in the Land of Porcelain*, which is displayed above the mantle of the room. Whistler conceived the decoration of the entire room as a sort of giant, Japanese-themed frame to compliment his painting. The floor-to-ceiling decorations of gold-on-blue and blue-on-gold peacocks with splendid flowing tails were painted over expensive Spanish leather paneling already installed in the room. Whistler even trimmed the border of the Persian rug in the room because the colors did not harmonize with his own. Whistler, in essence, passed on to Art Nouveau the popular peacock theme which so fascinated him. His asymmetrical placement of the birds and scale-like patterning of their feathers compared closely to the drawings of Aubrey Beardsley, another enthusiastic admirer of Japanese art, and of peacocks.

The Pre-Raphaelites

Two British admirers of the art of William Blake, Dante Gabriel Rossetti and Edward Burne-Jones, also contributed to the formative years of Art Nouveau. Rossetti was a member of the Pre-Raphaelite Brotherhood, a society of English painters and poets formed in 1848 to protest the low standards of English art. Burne-Jones was his student and a follower of the ensuing movement. They were admirers, like their friend William Morris, of medieval and Early Renaissance art—literally all painting before the influential Italian Renaissance painter, Raphael

The Depths of the Sea

Sir Edward Burne-Jones, 1887; watercolor on panel, replica of an oil painting of 1886; 77 x 30 in. (196 x 76.2 cm). Bequest of Grenville L. Winthrop, Fogg Art Museum, Harvard University, Cambridge, Massachusetts. Two weightless figures are buoyed up by the water surrounding them in this unusual underwater view, the only picture which Burne-Jones ever sent to the Royal Academy for exhibition. Pre-Raphaelite painters such as Burne-Jones were fascinated with drowning; this preoccupation, part of a general preference for morbid subjects, was also popular with Art Nouveau.

(1483–1520). The long, flowing robes of their often idealized and elongated figures, and the flattened ethereal quality of much of their painting, is evocative of many Art-Nouveau works.

Rossetti's unfinished painting, *Dantis Amor* (also called *Dante's Love*, 1859), used flame-like lines and patterning to highlight the haloed head of Jesus, while stars dotted the space around the central figure of poet, Dante Alighieri. Virtually all reference to space is abolished in this work (which was radical for Rossetti), and the surface is divided in two, diagonally, like a heraldic shield. In the lower right corner, Dante's great love, Beatrice, gazes up at him from a "window" made by an encircling moon. Rossetti's *The Annunciation* (1850) had the pale colors and an ethereal, bloodless quality to the figures that was also favored by Art Nouveau. The lily, a traditional symbol of the Annunciation and virginal purity in Christian art, became a favorite motif of Art Nouveau—as did white-robed figures that seem to float upon the surface of the picture.

In *The Golden Stairs* (1880), Burne-Jones chose to paint in a tall vertical format—the result of which was that the tall vertical format became a popular choice in Art Nouveau. Burne-Jones's procession of angelic women descending a spiral staircase has the weightless quality of the figures in Blake's *Whirlwind of Lovers*. The beautiful maidens, in their flowing robes, seem to float, rather than walk down the stairs. In Burne-Jones's *Depths of the Sea*, the figures are also weightless, buoyed up by the water surrounding them. This painting captures a sense of world-weariness and end-of-the-century disillusionment that was sometimes characteristic of Art-Nouveau art, particularly in the work of Aubrey Beardsley. This pessimism was another one of the contradictions of Art Nouveau, which also projected a profound optimism in creating "a new art for a new age."

World-weariness and pessimism are also associated with the work of the Symbolists, a group of writers and painters whose 1886 manifesto called for an art that suggested reality as it was *felt* rather than *observed*. The Symbolists wished for an art that appealed to emotion, not intellect. These ideas had a far-reaching influence on Art-Nouveau artists and can be felt in the work of several Art-Nouveau artists, including Paul Gauguin, Ferdinand Hodler, Edvard Munch, Gustav Klimt, Aubrey Beardsley, and Jan Toorop, among others.

The Symbolists

French painter Odilon Redon (1840–1916) developed his own visual dream world in close association with Symbolist poets such as Paul Verlaine and Stéphane Mallarmé. An example of this association is Redon's *The Green Death*, an evocative, if disturbing, vision of a floating masked figure of death springing forth from a snaky, monstrous tail. Redon's consistent depth of emotion is somewhat alien to the light-hearted decoration of Art Nouveau, but his swirling forms and preoccupation with the surface and end-of-the-century decadence are not.

Another French painter, Gustave Moreau (1826–98), was interested in ancient mythology which he painted with exotic, sometimes Oriental surroundings. He favored tragic themes, such as *Orpheus at the Tomb of Eurydice* (c. 1894). a picture illustrating the myth of Orpheus, the musician who challenged Hades (the god of the Underworld) to restore his wife, Eurydice, to life. Hades agreed, on the condition that Orpheus not look back until they reached the surface of the earth, but Orpheus could not resist his curiousity, and so lost Eurydice forever. Moreau's fascination with Oriental themes, although they did not specifically affect his style, was of the age of Art Nouveau. His figures are often weightless, and seem to float in a space that is only vaguely suggested.

Pierre Puvis de Chavannes (1824–98) was yet another French painter who influenced Art Nouveau. According to Robert Schmutzler, Puvis de Chavannes' "simplification of outlines and his reduction of all details to a complex of forms presented mainly in terms of surface . . . offered a kind of springboard for the later development of French Art Nouveau." As seen in *The Dream* (1883), Puvis de Chavannes could also favor seemingly weightless figures who are draped in shroud-like white. His paintings often convey a feeling of melancholy consistent with the "darker side" of Art Nouveau and turn-of-the-century sensibilities. In *The Dream*, the prone and dreaming figure is visited by three floating angel-like apparitions, one of whom scatters flowers onto the water in a mysterious tribute.

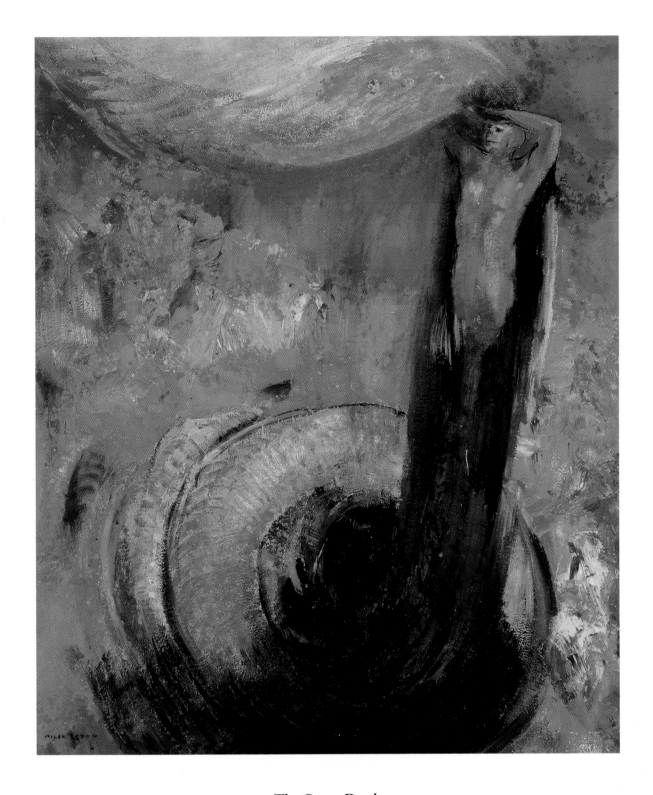

The Green Death

Odilon Redon, c. 1905–16; oil on canvas; 22 3/8 x 18 3/4 in. (57 x 47 cm). Louise Reinhardt Smith Bequest, The Museum of Modern Art, New York.
Redon developed his own visual dream world in close association with Symbolist poets such as Paul Verlaine and
Stéphane Mallarmé, whose work stressed the emotional effects of their subjects. In this disturbing piece, a mask-faced apparition
of death springs forth from a curled and monstrous tail. The Symbolist moment was in touch with the mood of
end-of-the-century decadence which also preoccupied some artists of Art Nouveau.

23

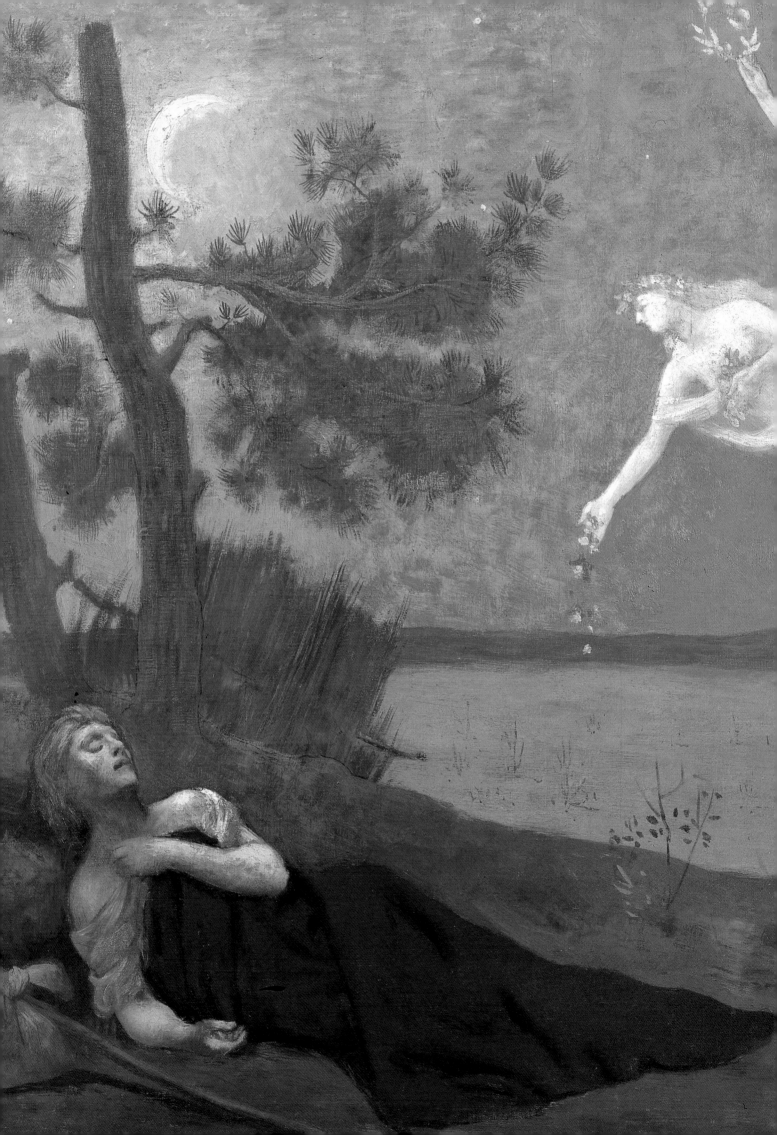

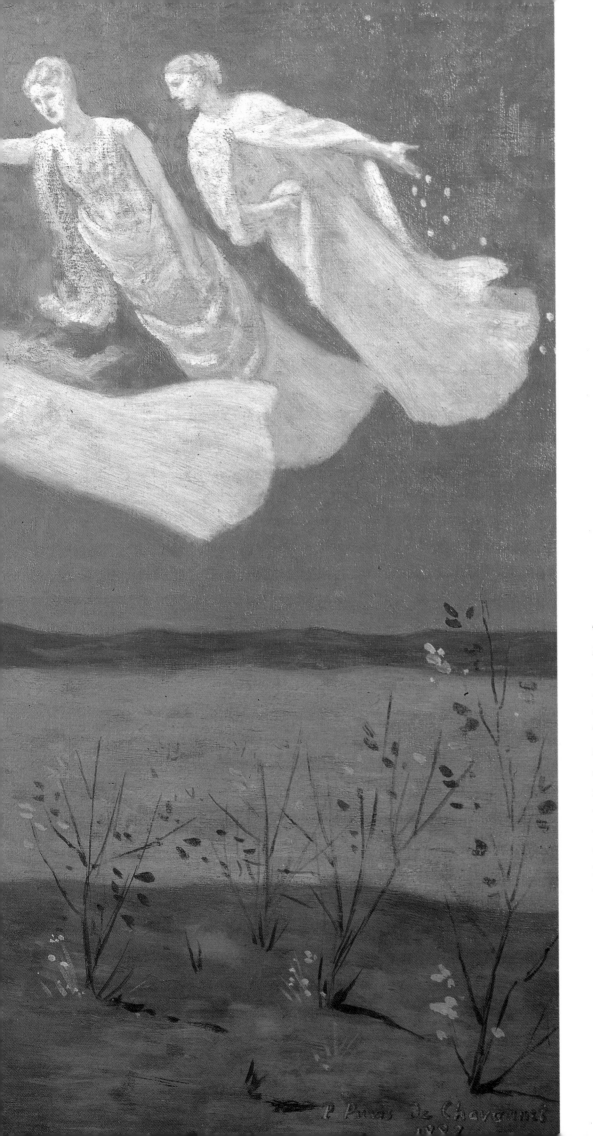

The Dream

Pierre Puvis de Chavannes,
1883; oil on canvas;
31 1/2 x 29 3/8 in.
(80 x 100 cm). Louvre, Paris.
Through the use of
simple outlines and few
details, Puvis de Chavannes
reduced painting mainly
to an art of surface, a style
that was of great interest
to the pioneers of Art
Nouveau. Three floating,
white-clad figures hover
over a sleeper at the water's
edge, scattering flowers
in a mysterious tribute.
The general feeling of
melancholy is consistent with
Art-Nouveau sensibilities.

Architects and Illustrators

If Whistler, the Pre-Raphaelites, and the Symbolists set the stage for Art Nouveau, then Henry van de Velde, Victor Horta, Hector Guimard, and Aubrey Beardsley pioneered and popularized the style. Their works were widely seen, widely discussed and admired, and in short, con-

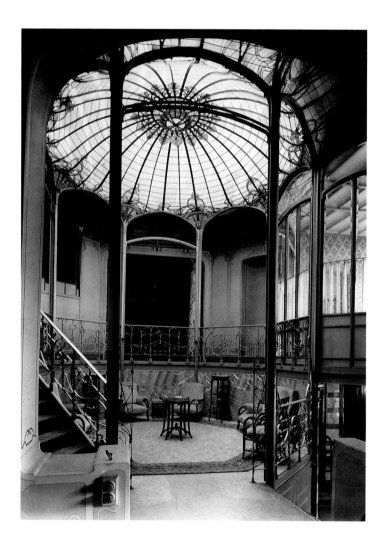

Hall of the Van Eetvelde House

Victor Horta, 1895. Brussels.

Horta was internationally famous as a master of Art-Nouveau architecture. This skylight displays his well-known facility with iron and glass as a construction medium. The fanciful curves of the supporting columns are echoed in the writhing motion of the floral-motif light fixture in the foreground.

tributed greatly to the formation and subsequent development of Art Nouveau.

Victor Horta, the Belgian architect whose facility and freedom with wrought-iron ornament—evident in his famous Tassel Residence—was also much imitated and admired. His mature works, the Solvay Residence (1895–1900) and the Van Eetvelde House (1895), were further examples of his prototypical Art-Nouveau style. Horta designed every aspect of these houses, and for the interiors he gave himself free reign to experiment with the curving possibilities of line in the furniture and fixtures. The almost living aspect of the light fixtures was based on organic plant forms, as were the details of the chairs, cabinets, and floor decorations. The skylight of the Van Eetvelde House demonstrated Horta's facility with iron and glass as a construction medium. Horta was also well known for his iron and glass building, the Maison du Peuple ("House of the People") in Brussels. This now-demolished structure is considered to have displayed, for its time, a particularly innovative use of iron and glass building materials.

Hector Guimard (1867–1942), a French architect and furniture designer who was influenced by Horta, became one of the most original Art-Nouveau architects. Guimard is best known for his innovative entrances to the Paris Métro (subway) stations (c. 1900), which are still landmarks in that city. The streetlights that are woven into the design of these ornate wrought-iron and glass subway entrances are whimsically animated, like some large exotic plant. The green paint applied to the iron enhances this illusion. Guimard's design for the entrance and hallway for Castel Béranger (1894–98), a luxury apartment house, was notable for the asymmetrical ironwork of the gateway, and the freely conceived lines and flowing curves of the supporting braces. A similar freedom of line and asymmetry can be seen in a famous desk of his design.

The distinctive graphic work of Aubrey Beardsley was widely seen and influential in the development of Art Nouveau. This influence rests partly in the

uniqueness of Beardsley's vision, but the portability and reproducibility of his medium also played a part—the books and periodicals that were the primary vehicles for Beardsley's art traveled great distances easily. Beardsley's titillating treatment of decadent and erotic subjects, such as his illustrations for Aristophanes' *Lysistrata*, also undoubtedly contributed to his wide appeal. A particular illustration of Beardsley's style is *How Queen Guenever Made Her a Nun* (1893–94), a plate from his first illustrated book for Sir Thomas Malory's *Morte d'Arthur* (The Death of Arthur). According to Malory, Queen Guinevere, wife of the legendary King Arthur, had retired to a convent after her disastrous affair with Sir Launcelot, the advent of which foreshadowed the downfall of Camelot. In the illustration, the asymmetrical frame is filled with twining vegetative ornament around the flattened silhouette of the nun's figure. It is an elegant line, as well as a masterful use of black on white and white on black. Though Beardsley's style shows strong Japanese and even medieval influences, the result is uniquely his own.

After examining the work of these pioneers and forerunners of Art Nouveau, it is easy to understand how the style was hailed in its day as new, innovative, and exciting. Even today, after a century of change, the fresh approach of these artists remains appealing.

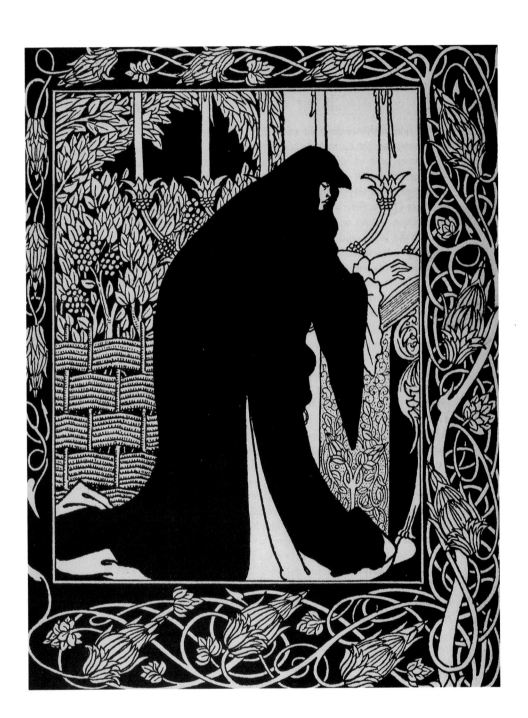

How Queen Guenever Made Her a Nun

Aubrey Beardsley, 1893–94; book plate from Sir Thomas Mallory's Morte d'Arthur.
The New York Public Library, Astor, Lenox and Tilden Foundation, New York.

In a prime example of Beardsley's early style, Queen Guinevere, wife of the legendary King Arthur, is shown as an elegant silhouette. In *Le Morte d'Arthur*, Guinevere's tragic love for Sir Lancelot ended with her retiring to a convent. The stylized plant forms of the border, typically Art Nouveau, show how Beardsley's mastery of pattern and line was greatly influenced by Japanese prints.

"Whiplash" Wall Hanging

Hermann Obrist, 1895; embroidered in gold colored silk on blue green–grey wool, executed by Berthe
Ruchet; 46 7/8 x 72 1/4 in. (117 x 182.9 cm). Modemuseum in the Münchner Stadtmuseum, Munich.
Obrist's design shows the whole plant, including its bud, flower, leaves, and root. The piece
was originally named "Violets of the Alps," but when a critic compared the frantic movement
of the plant's stem to the "violent curves occasioned by the crack of a whip," the name
"whiplash" curve was born, and soon became a signature of Art-Nouveau style.

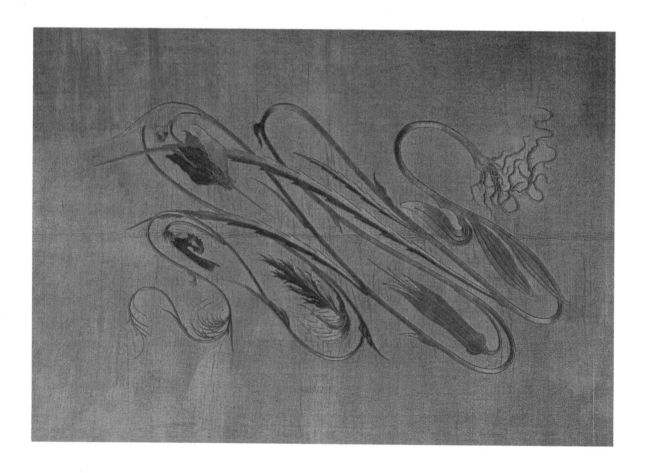

The Dream of Jacob

William Blake, 1808; pen and watercolor; 14 9/16 x 11 1/2 in. (37 x 29.2 cm). Trustees of the British Museum, London. The swirling spiral form of Jacob's ladder prefigures the arabesques of Art Nouveau. Jacob's vision of the ladder extending from earth to heaven, on which the angels of God ascend and descend, is found in the Book of Genesis 28:12. The simple, graceful forms of Blake's angels became an inspiration to the artists of the Art Nouveau movement.

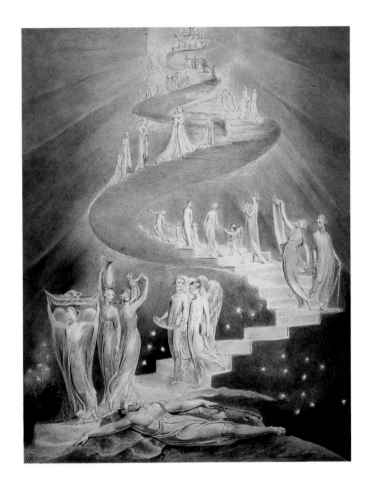

Woman in a Red Robe

Jozsef Rippl-Ronai, 1898; tapestry;
90 x 43 3/4 in. (230 x 125 cm).
Museum of Fine Arts, Budapest.
The flat, curving, linear style
of this tapestry—embroidered
by the artist's wife, Lazarine
Boudrion—is fully Art
Nouveau in concept, and
the woman admiring the
flower is also part of a unified
pattern of shape and line.

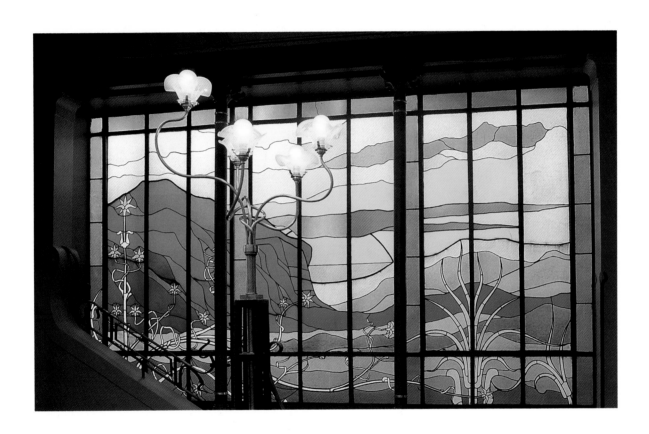

Tiffany Stained-Glass Window
from the Tassel Residence

Louis Comfort Tiffany, 1892–93. Musée Horta, Brussels.
The Art-Nouveau windows, columns, floor tiles,
wall decorations, skylights, door handles, furniture,
and even the keyholes echo the style of Horta's
architecture in a stunning synthesis of form.

Following page:
Desk (from the artist's house)

Hector Guimard, c. 1899, remodeled after 1909;
olive wood with ash panels, 29 3/4 x 140 3/8 x 47 3/4 in.
(73 x 356.5 x 121.3 cm). Gift of Madame Hector
Guimard, The Museum of Modern Art, New York.
Art-Nouveau artists were known for their versatility.
Guimard, a furniture designer as well as an architect,
applied the same asymmetrical, linear, Art-Nouveau
forms to this desk as he did to his building designs. Here,
curves serve to unify the desk into an organic whole.

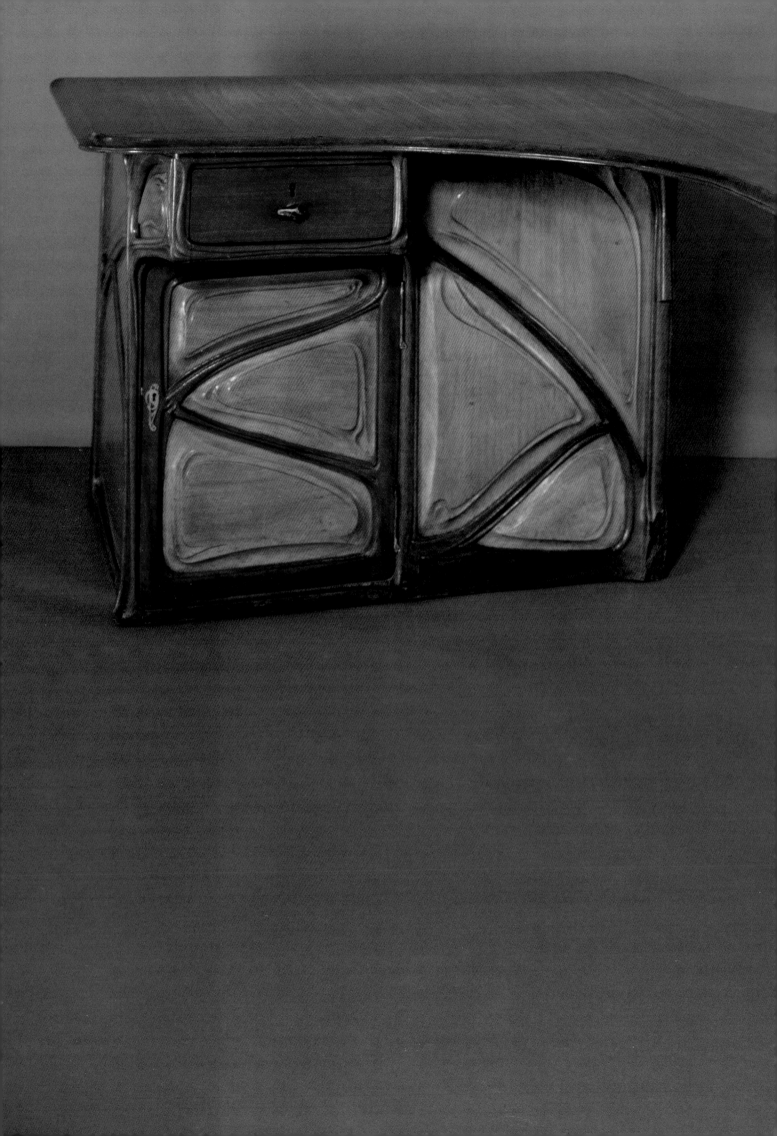

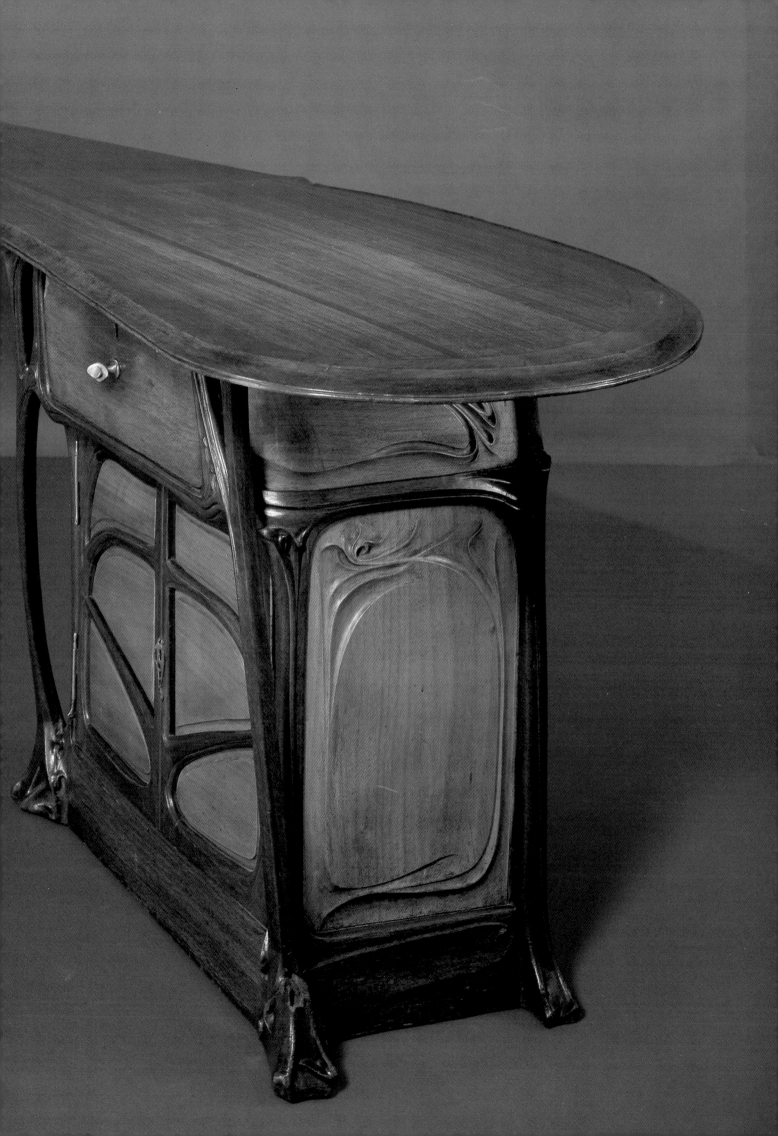

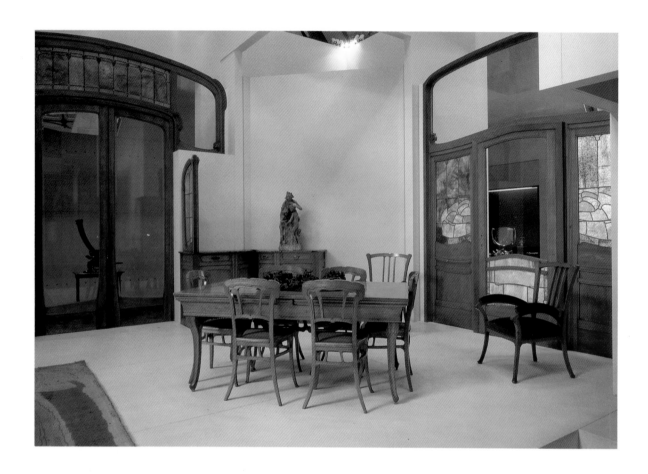

Dining Room of the Solvay Residence

Victor Horta, 1899–1900. Brussels.

Horta designed every aspect of his interiors to harmonize into a
unified whole. The window casements, chair legs, table legs, and
woodwork were designed to compliment the curves of the architecture.

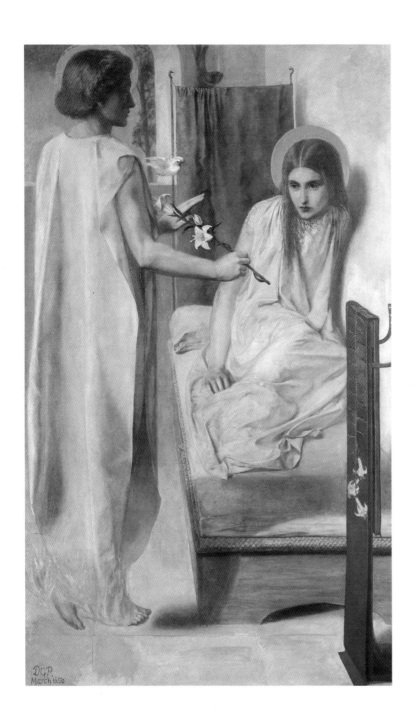

Ecce Ancilla Domini (The Annunciation)

Dante Gabriel Rossetti, 1850;
canvas mounted on wood;
28 1/2 x 16 1/2 in. (72 x 42 cm).
Tate Gallery, London.
The later Art-Nouveau artists
favored pale colors and floating
white-robed figures—not unlike
what Rossetti uses in this inter-
pretation of the moment when
the angel Gabriel reveals to
the Virgin Mary her conception
of Christ. The lily which
the angel holds, a Christian
symbol of purity, became a
favorite motif of Art Nouveau.

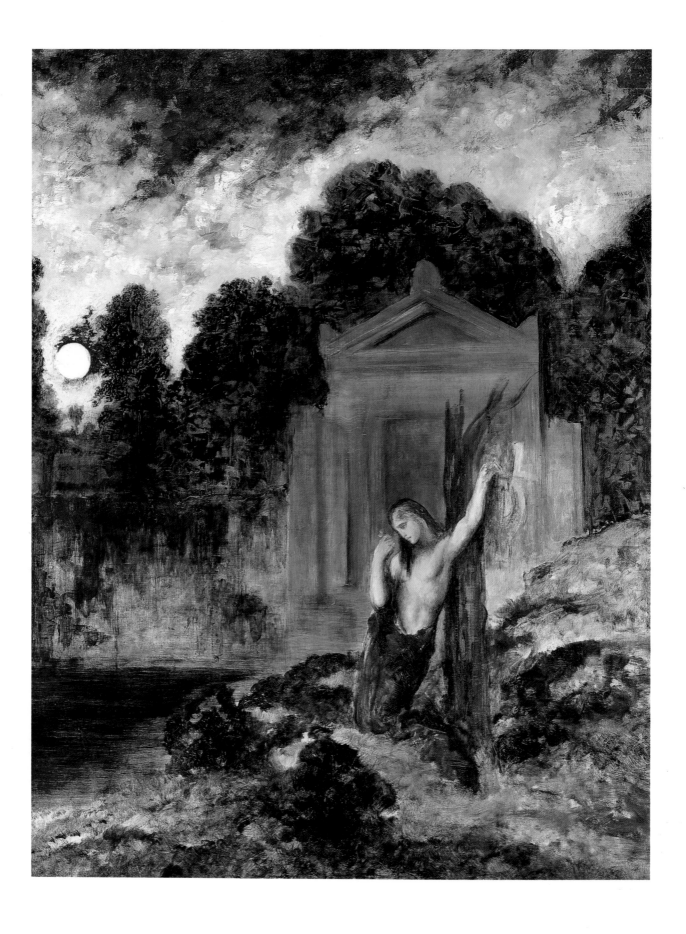

The Sun Chariot of Apollo with Four Horses

Odilon Redon, c. 1905; oil on canvas;
26 x 32 in. (66 x 81 cm).
Anonymous gift, The Metropolitan
Museum of Art, New York.
Redon applies the visual dream
world he developed in his art to
the subject of Apollo, the ancient
Greek god of the sun, who drives
his chariot across the sky. Instead
of creating three-dimensional
space, Redon concentrates on the
surface of the canvas, and on the
simplified curving forms of the fiery
horses and their energetic master.

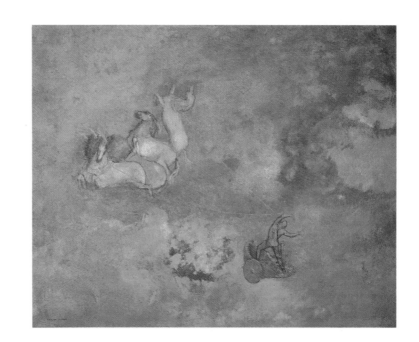

Orpheus at the Tomb of Eurydice

Gustave Moreau, c. 1894; oil on canvas; 68 1/8 x 50 3/16 in.
(173 x 128 cm). Musée Gustave Moreau, Paris.
Orpheus, the musician of Greek mythology, lost his great love
Eurydice forever because he could not resist looking back at her
beauty as he rescued her from the underworld—although he had been
expressly forbidden to do so. Moreau has painted the tragic figure of
Orpheus kneeling by a tomb that is set in a vaguely defined landscape.

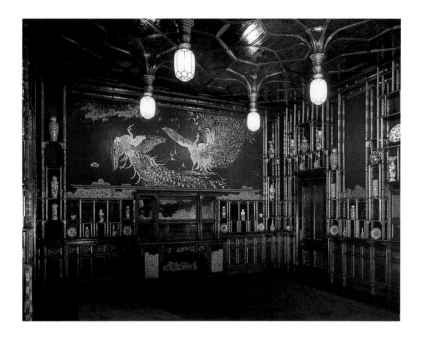

The Peacock Room

James Abbott McNeill Whistler, 1876–77; oil on wood, canvas, and leather.
The Freer Gallery of Art, Smithsonian Institution, Washington, D.C.
The decoration of this room is Whistler's homage to Japanese art. Whistler
gave to Art Nouveau the popular Japanese motif of the peacock, which so
fascinated him. He painted gold and blue peacocks over the expensive
Spanish leather paneling that was already installed in the room, then trimmed
the border of the Persian rug, to better harmonize with his color scheme.

Nocturne in Black and Gold: The Falling Rocket

James Abbott McNeill Whistler, c. 1875; oil on wood; 23 5/8 x 18 1/2 in.
(58.6 x 45.9 cm). The Detroit Institute of Arts, Detroit, Michigan.
When Whistler's critic, the art historian John Ruskin, called this
painting "a pot of paint flung in the public's face," he was referring
to its extremely abstract, Impressionistic quality and apparent lack
of subject—quite unheard of at the time. Whistler was interested in
capturing the fleeting effects of light in the manner of the Impressionists.
He was also interested in the relationship between music and painting
and often called his paintings nocturnes, symphonies, or harmonies.

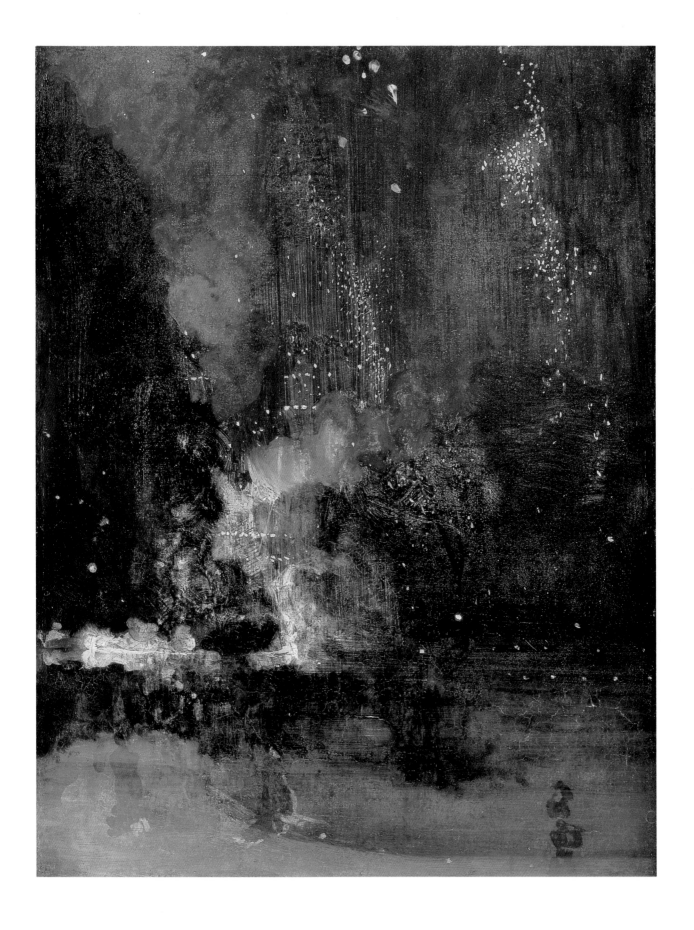

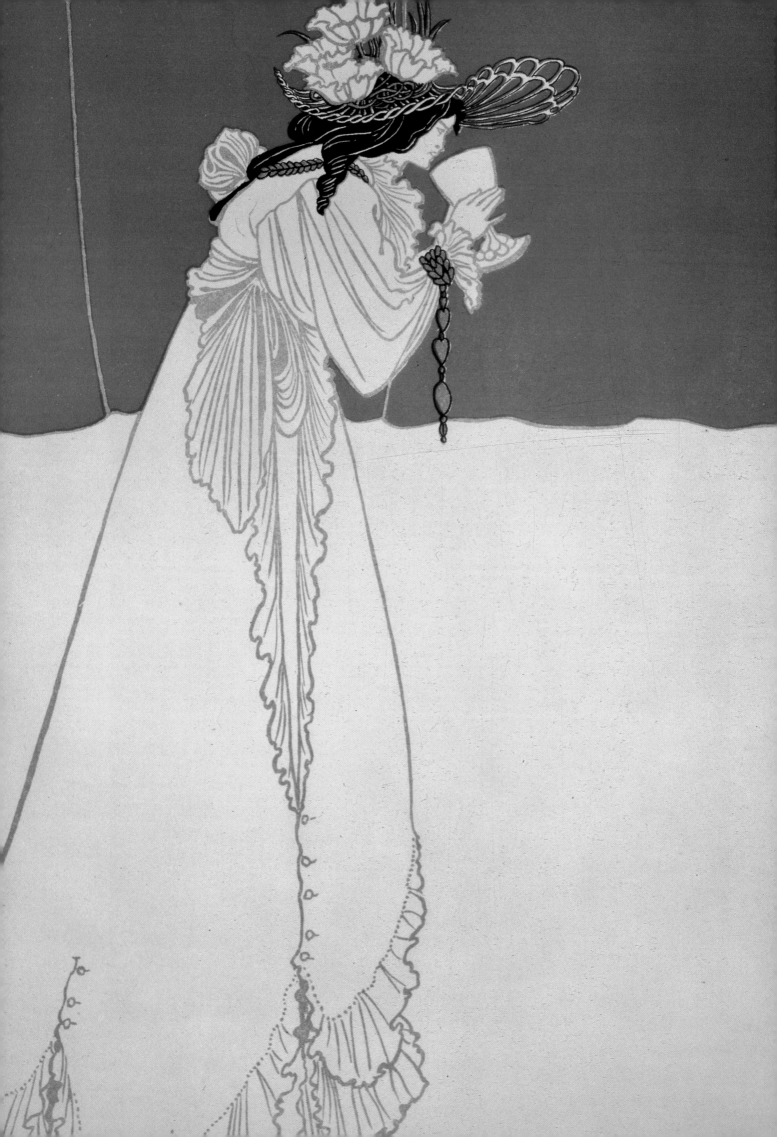

A TASTE FOR DECORATION

Art Nouveau has been considered by some critics to be primarily a graphic style. Although this is a very narrow view, books were a major and important focus of Art-Nouveau expression, and the design flourished not only in book illustration, but also on bookbindings and in typography.

The Art of the Book

Aubrey Beardsley's work was almost exclusively confined to the realm of illustration for books and periodicals. His illustrations were newly bold and original; they created a critical sensation when published in the premier number of *The Studio* in 1893. In addition, his technically precise drawings appeared in the periodicals *The Yellow Book* (begun 1894) and *The Savoy* (begun 1896). Although Beardsley worked almost exclusively in black and white, sketching his work in pencil and then drawing with India ink, he also made a few color illustrations. One of these was *Isolde*, c. 1895. Although the tale of the lovers Tristram and Isolde is drawn from the medieval legends of King Arthur, Beardsley's Isolde is dressed not in a gown typical of the medieval period, but in a dress and hat that represent the height of Parisian fashion of Beardsley's own time—typical of his disregard for historical period. He also occasionally dressed figures in Japanese kimonos, with no regard to where the story he was illustrating actually took place.

Beardsley's *Poster for a Book Publisher* (c. 1895) also displayed his tendency toward exaggeration and parody. The billowing curves of the woman's figure, the plume in her hair, and the wings of the armchair in which she sits are exaggerated for the decorative impression that they convey, and the humor imparted to the subject. Beardsley's art was founded on the art of Edward Burne-Jones, William Morris, Japan, and James Whistler's "Japanism." His sensitive outline and taut contours also owe a debt to Greek vase painting and the expressive silhouettes of French poster artist Henri de Toulouse-Lautrec. Both a dandy and a prodigy, Beardsley lived in a world of surface and ornament—working by candlelight in a room with black walls and furniture, with the curtains perpetually drawn—that hinted of mystery, magic, and danger.

Isolde

Aubrey Beardsley, c. 1895; color lithograph; 9 3/4 x 5 7/8 in.

(24.3 x 14.9 cm). From The Studio VI, *London, 1896. Private collection.*

Isolde sips from a goblet that contains, according to Arthurian legend, a love potion that will bind her eternally to her lover, Sir Tristram. She is dressed in the stylish Parisian fashion of Beardsley's time, not in a medieval gown as one might expect, and her height is much exaggerated. Beardsley often disregarded proportion, anatomy, gravity, shadows, and space in his drawings—striving instead for the overall decorative impact.

Book Bindings

English designer and illustrator Charles Ricketts (1866–1933) was a good friend of the writer Oscar Wilde (1854–1900) and a member of Beardsley's circle. In contrast to Beardsley, Ricketts relied on the forms of nature, and he decorated most of Oscar Wilde's books. His illustrations are fanciful and original, filled with dense swirling designs where human figures and plant and animal life are woven into an intricate carpet of surface design. Ricketts was inspired by many of the same sources as Beardsley, such as Rossetti, Burne-Jones, Whistler, Japanese art, and Greek vase painters, but his style took a different and original turn. In the cover design for Wilde's *A House of Pomegranates* (1891) Ricketts creates a decorative design from the asymmetrical branches of the pomegranate tree and a carpet of blooming crocus flowers, and overlays them with the symbols of peacock, fruit bowl, and fountain. Critics were outraged by Ricketts' design, and compared his fountain to an upside-down top hat. But Oscar Wilde maintained that there were only two people the book design had to please—himself and Charles Ricketts.

The art of bookbinding had remained stubbornly conservative up until the time of Art Nouveau. Typically, gilt decorated bindings were based on seventeenth-and eighteenth-century designs, composed of symmetrical, lacy floral motifs that were intended to harmonize with the rest of the buyer's collection. In the context of the persistent conservatism of binding designs, critical reactions to Ricketts' innovative designs are more understandable. In France as well as England, the old binding style was replaced with bold, asymmetrical designs which sometimes spread over the entire surface of the book and often made symbolic reference to the work within. Luxurious, artist-illustrated limited editions also became popular at this time, which created a further demand for new and innovative bindings.

Book Illustrations

The Art-Nouveau period in England also produced many children's book illustrations which are still enjoyed today. The work of Walter Crane (1845–1915) owed a debt to William Blake, but was

Binding for Oscar Wilde's *Sphinx*

Charles Ricketts; 8 3/4 x 7 in. (22.2 x 17.8 cm).

The Pierpont Morgan Library, New York.

English designer and illustrator Charles Ricketts (1866–1933) was a good friend of the writer Oscar Wilde and a member of Aubrey Beardsley's circle. Ricketts decorated most of Wilde's books—here, the sphinx, the ultimate *femme fatale*, has been transformed from ancient mythology into Art-Nouveau design.

The Little Lilies of the Vale

Walter Crane, 1889; book plate from Flora's Feast. *The New York Public Library, Astor, Lenox and Tilden Foundation, New York.*

These charming, Art-Nouveau illustrations for a book of children's verse show flowers in a garden. Each flower is personified as it awakens, season by season, from a winter's sleep. The delicate watercolor tints are a perfect counterpart to Crane's sinuous lines, which are also complimented by his handwritten Gothic text.

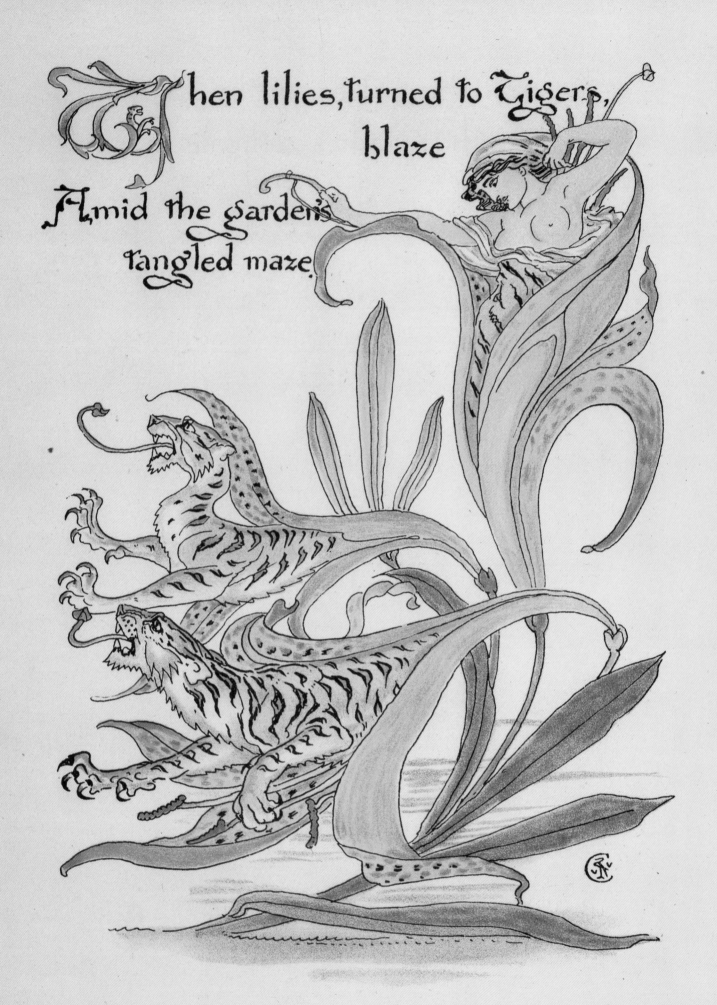

Then lilies, turned to Tigers, blaze
Amid the garden's tangled maze.

The little Lilies of the Vale,
White ladies delicate & pale;

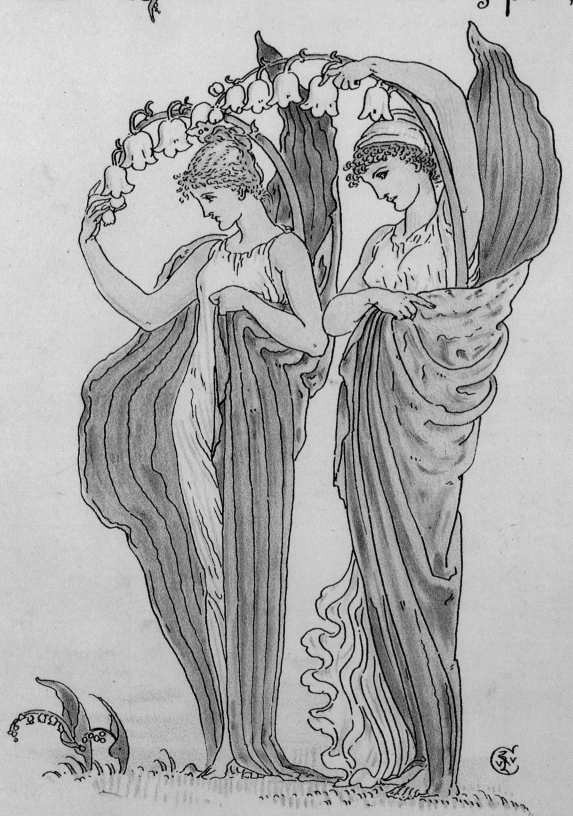

also delightfully original. An active member of the English Arts and Crafts movement, Crane founded the Arts and Crafts Exhibition Society of London in 1888. His illustrations for his own book of children's rhymes, *Flora's Feast* (1889), personify flowers in a garden as they are awakened, season by season, from their winter's sleep. The drawings have a universal appeal that is heightened by Crane's elegant and undulating lines. The delicate watercolor tints are a perfect counterpart to the sinuous lines, which are also complimented by the hand-lettered Gothic text.

Kate Greenaway (1846–1901), one of the most celebrated children's illustrators of her time, influenced popular taste, fashion, and manners in England for several generations. Greenaway's illustrations often have more in common with the medievalizing tendencies of the Arts and Crafts movement than they do with the visionary William Blake, or the sinuosity of Aubrey Beardsley's creations. However, in the illustration which serves as a frontispiece for *The Pied Piper of Hamelin* by Robert Browning (1888) there is a spirit of Art Nouveau in the flowing hair and white gowns of the little children who dance in a flowering orchard to the Piper's tunes.

Another graphic artist who was also an architect, Arthur Heygate Mackmurdo (1851–1942), has been credited with creating the first truly Art-Nouveau illustration in his title page from *Wren's City Churches* of 1883. Mackmurdo uses an asymmetrical pattern of tulips stylized into vigorous flaming shapes to surround the words of the title, which are also bent in undulating motion. On each side of the page stand roosters of exaggerated length. The forms of the

Then Lilies Turned to Tigers Blaze

Walter Crane, 1889; book plate from Flora's Feast.

The Pierpont Morgan Library, New York.

Walter Crane's delightful illustrations (forty in all) of flowers awakening enjoyed a universal appeal among childen and adults alike. The drawings, which were lithographed with great accuracy, had delicate watercolor hues laid in afterwards on the outline proofs.

"Tokyo" Wallpaper

Charles Annesley Voysey, 1893; textile. Victoria and Albert Museum, London.

Voysey favored stylized natural forms in his textile and wallpaper designs, using thick outlines and little detail to create decorate surface patterns. His designs bridge the English Arts and Crafts movement and pure Art Nouveau.

tulips are pulled into odd curves by seemingly opposed forces of wind or water. Mackmurdo's designs for fabrics displayed a similar pull of opposing forces in their curves. In his *Wren's City Churches* illustration, Mackmurdo introduced motifs which became popular throughout Europe.

Mackmurdo's student, the architect and designer, Charles F. Annesley Voysey (1857–1941), was at first influenced by Mackmurdo in his textile and wallpaper designs. However, his patterns were typically more conservative and showed more restraint than Mackmurdo's. Voysey's "Tokyo" wallpaper of 1893

showed his own distinctive style. He favored stylized birds, enormous flowers, and inexplicable shapes which he combined in a world of purely decorative surfaces. His overlapping forms are defined by thick outlines, while details are simplified or omitted. In short, he constructed a surface of form and line that was the essence of Art Nouveau.

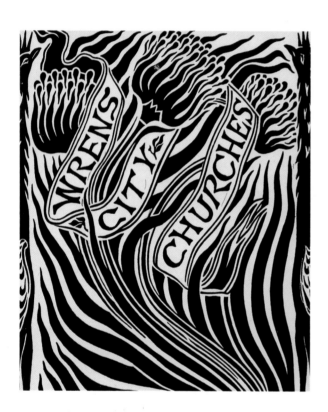

Title Page from *Wren's City Churches*

Arthur Heygate Mackmurdo, 1883; book plate. The New York Public Library, Astor, Lenox and Tilden Foundations, New York. This design has been called the first truly Art-Nouveau illustration. Mackmurdo's Century Guild, which he founded with Selwyn Image in 1882, produced Art-Nouveau fabrics and book designs that were at the forefront of the movement. Mackmurdo's designs depended on strong counter-rhythms for their effect, a point which was much imitated by other designers in Europe. In this design, the stylized tulips are pulled one way, while their flame-like leaves are drawn in the opposite direction.

A French Potpourri

While English artists were concentrating on the art of the book, other forms of Art Nouveau were developing in France. With advances in lithography and advertising, the poster became a major and widely seen public vehicle of expression. The poster, like the book, crossed national boundaries and carried the message of the new style with ease.

Jules Chéret (1836–1932), the French graphic artist and scenery painter who established his own lithographic printing press in 1866, is known as the originator of the modern poster. Chéret's posters were notable for their bold, linear patterning and freely drawn lettering. For a time, beginning in 1893, he fell under the influence of the decorative flat patterns of Henri de Toulouse-Lautrec (1864–1901).

Chéret's Folies-Bergère poster (1893) shows the flattening of form he used while under Toulouse-Lautrec's influence. It portrays the American dancer, Loïe Fuller, whose act included long silk veils raised up high on bamboo sticks in a wash of colored electric lights (a novelty for Paris at that time). The movements of Loïe Fuller's draperies provided almost the ideal subject for Art-Nouveau artists because of the opportunity for showing masses of undulating lines, while her innovative lighting ideas and dance style started a new trend in entertainment.

Folies-Bergère, La Loïe Fuller

Jules Chéret, 1893; lithograph; 43 3/8 x 32 1/4 in. (110 x 82 cm). The Museum of Modern Art, New York. Art-Nouveau artists were captivated and inspired by the performances of American dancer Loïe Fuller, who swirled her long veils—which she supported on bamboo sticks—in a wash of changing, colored electric lights. (Electricity was a novelty in Paris at that time, and no performer had yet thought of exploiting it.) The swirling skirts of Fuller's dance were an ideal Art-Nouveau subject, providing a wealth of undulating curves.

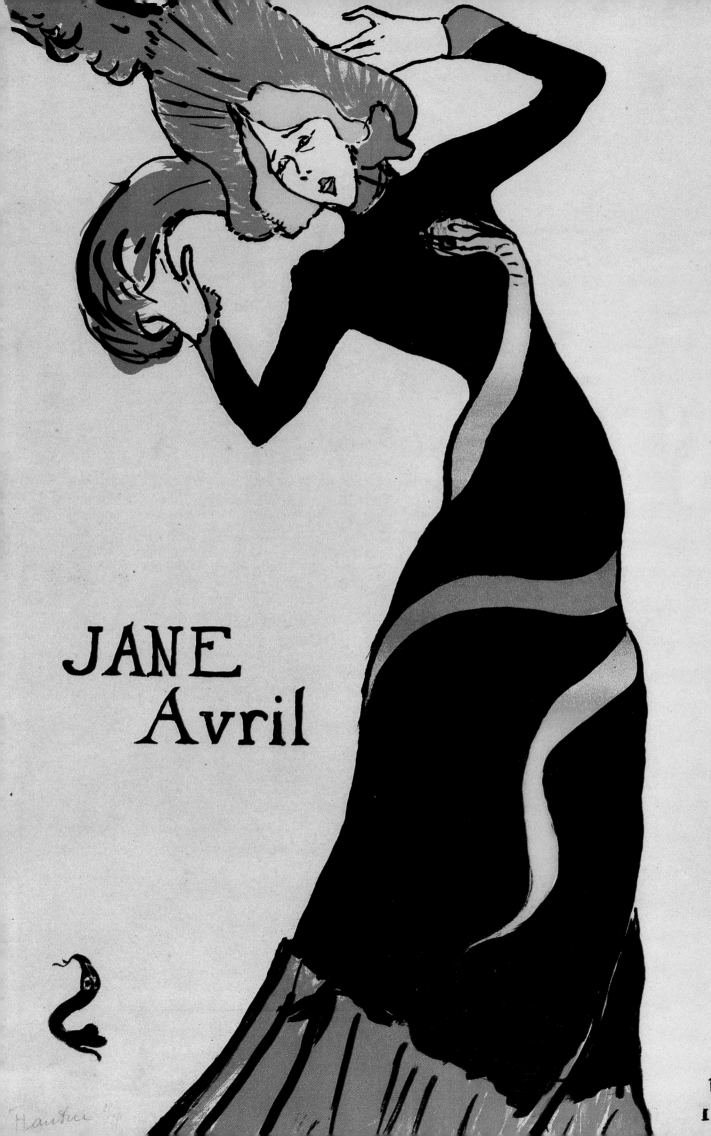

JANE
Avril

H. Stern. Paris.

1899

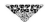

Henri de Toulouse-Lautrec

There were many popular women entertainers in Paris at this time, indeed women were freer to participate in all the arts in increasing numbers. Poster artist and painter Henri de Toulouse-Lautrec immortalized the period with many unforgettable images of entertainers. Lautrec's posters became so popular at one point that Parisians actually went around peeling them off the walls before the glue was dry to add them to their personal collections.

Lautrec made many posters celebrating the singer and dancer, Jane Avril, who performed at cabarets in the bohemian Montmartre section of Paris. Lautrec's vision of Jane Avril was flattering; he helped create her image with his posters and actively promoted her career—indeed, he is credited with discovering her. Lautrec, who considered himself monstrously ugly and suffered from a crippling form of hereditary dwarfism, was fascinated with Jane Avril's lithe figure, red hair, creamy skin, and arresting features. A later poster of *Jane Avril* from 1899, however, was considered too extreme or ambiguous by her promoters and was never used for publicity purposes. It shows, however, a peak of Lautrec's Art-Nouveau style. Jane Avril's figure and hat are distorted into impossible curves, while a rainbow-colored snake encircles her hips and waist. Avril's arms are raised and her mouth open in what some critics considered a parody of Edvard Munch's painting, *The Cry*, which had been recently reproduced in a popular magazine. Lautrec's frame of mind when he designed this poster was

probably poor; he was suffering from advanced alcoholism, and probably syphilis as well, and died two years later.

Another French graphic artist, Eugène Grasset (1841–1917), was so well admired that in 1894 that he had a one-man show of posters in Paris.

Exposition E. Grasset, Salon des Cent

Eugène Grasset, 1894; poster; 23 1/4 x 14 3/4 in. (59 x 37.5 cm). Gift of Ludwig Charell, The Museum of Modern Art, New York. Grasset's white-clad woman holding a long-stemmed flower is a typical Art-Nouveau subject. The artist has simplified the forms and kept detail to a minimum in this poster for his one-man show in Paris at the Salon des Cent. Grasset's work was even more popular in England than it was in France.

Jane Avril

Henri de Toulouse-Lautrec, 1895; lithograph; 10 1/2 x 8 3/8 in. (26.7 x 21.3 cm). Gift of Abby Aldrich Rockefeller, The Museum of Modern Art, New York. Lautrec made many posters celebrating the singer and dancer, Jane Avril, whose career he promoted. Lautrec, who considered himself monstrously ugly, was fascinated with Avril's lithe figure, red hair, creamy skin, and expressive features. Here Lautrec distorts her figure and hat into impossible Art-Nouveau curves, while a snake encircles her hips and waist.

Grasset's work was even more popular in England than it was in France. The poster Grasset designed for his show was fully Art Nouveau in conception, although he was never as daring, and never pushed design as far, as Lautrec. Grasset's chosen theme of a woman holding a flowering plant is typically Art Nouveau, as is the curving, curling design of her hair and the long, expressive plant stem. Grasset was also known for creating a typographic design (known as Grasset type) that, with its clear reference to hand-lettering, moved type design toward an Art-Nouveau style.

By 1900, Art Nouveau was firmly established and widely popular in France. In that year the designer René Beauclair, who is considered part of the second wave of Art Nouveau, published his book *Ornamental Patterns*, a compendium of patterns suitable for wallpaper or textiles that exemplify Art Nouveau. By the turn of the century, the flat, abstracted use of plant forms woven into surface designs with elegant, sinuous curves were a familiar motif. Pastels and the color combinations, with a preponderance of yellow, green, and mauve, were also typically Art Nouveau.

The School of Nancy

The craftsmen of France became world-famous for their luxury design and production of jewelry, glass, furniture, and other decorative objects. This flowering of design was centered not in Paris, but rather in the town of Nancy, in the northeast region of Lorraine. Nancy had also been a center of the glassmaking industry, dating back to the fifteenth century, and it was architecturally dominated by the ornate eighteenth-century Rococo style.

Among the Nancy artists was Emile Gallé (1846–1904). Born into a family of potters and glassmakers, Gallé became a brilliant innovator in glassmaking. After studying philosophy, literature, and botany—and an appropriate period of apprenticeship—he opened his own glass workshop in Nancy in 1874, adding cabinet making in 1884. Gallé refined unusual glassmaking techniques such as the use of multi-color layering, relief decoration, and acid etching, and his furniture designs were notable for spectacular inlay work.

Influenced by the Symbolists, Gallé incorporated their imagery and included their poetry as actual inscriptions on his work, which was often showcased at Bing's Art-Nouveau gallery in Paris. Gallé's fine workmanship and innovative designs were immensely popular, and although his shop remained in operation until 1914, no truly original work had been produced since his death in 1904.

Gallé's unusual forms and techniques can be seen in his vases, where he combines a strong Japanese influence with an Art-Nouveau preference for natural forms, and adds a hint of Rococo to create a distinctive and personal creative style. Gallé adapted the Oriental themes of chrysanthemums, irises, water lilies, dragonflies, butterflies, sea creatures, and seaweeds to his media. His final work, the famous *Butterfly Bed* (1904), used sumptuous mother-of-pearl inlays to evoke the ephemeral day and the mysteries of night.

Vase

Emile Gallé, c. 1895–1900; multi-colored, carved, and etched glass. Musée des Beaux-Arts, Nancy.
Gallé was at the forefront of the French innovations in Art-Nouveau glassmaking, which centered around his workshop in Nancy. Gallé refined unusual glass techniques such as acid etching, relief decoration, and the use of multi-color layering. His subjects—often inspired by Japanese themes—were flowers, insects, and sea life.

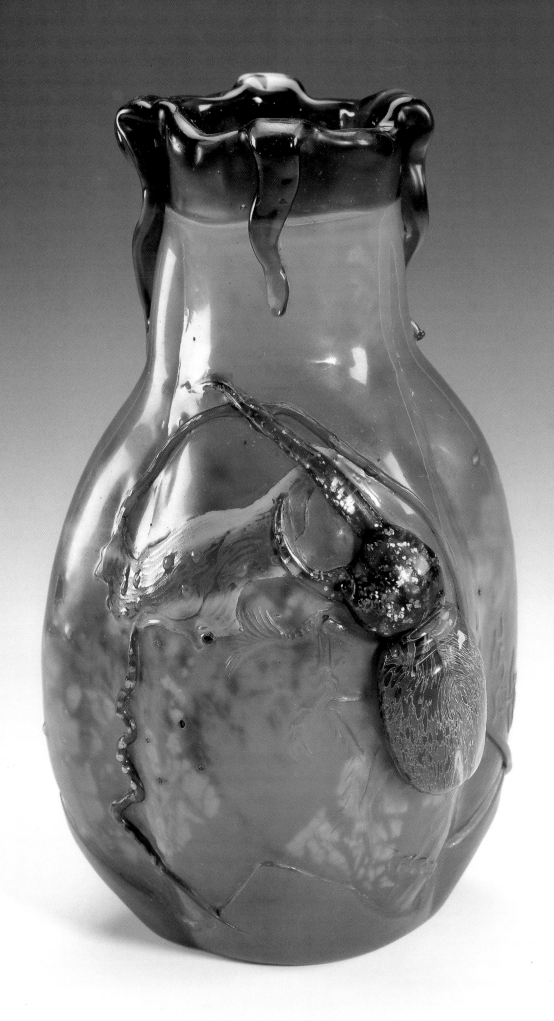

Furniture and Jewelry

Among the many important French Art-Nouveau furniture designers were Victor Prouvé, Jacques Gruber, Eugène Gaillard, and Georges de Feure. In addition, one of the most talented, Louis Majorelle (1859–1926), was from a family in Nancy that specialized in making period furniture. Majorelle's first designs were in the Rococo manner, made before he began working in the Art-Nouveau style under the influence of Gallé in 1897. Majorelle was interested

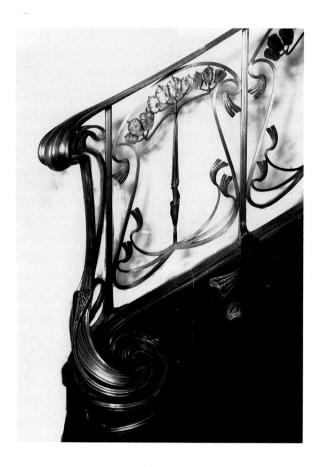

Metal Balustrade for a Staircase

Louis Majorelle, c. 1900; 33 x 93 in.

(85 x 210 cm). Musée des Arts Decoratifs, Paris.

Majorelle belonged to the French design movement centered in Nancy. He was also known for his furniture designs, which used bronze embellishments to accent the dark colors of rosewood and mahogany. This stair railing uses metal expertly in free-flowing curves. The stylized plant forms are based on a plant known as honesty which was popular with designers of Art Nouveau.

in the elegance of line but also in the plasticity of shapes. In fact, he was known to model his furniture designs in clay before he executed them in wood.

Majorelle's best furniture was produced between 1902 and 1906. He favored hardwoods such as mahogany and rosewood, which actually did not lend themselves to sculptural treatment, but he got around this by accenting the furniture with bronze embellishments, which contrasted nicely with the dark woods. Majorelle's metal balustrade for a staircase (c. 1900) shows his free handling of the metal and his elegant sense of Art-Nouveau ornament.

Another notable furniture maker, Eugène Vallin (1856–1925), was a friend of Louis Majorelle and Victor Prouvé, a carpenter specializing in church furniture and building restoration, Vallin was taken on by Gallé to create modern furniture for his workshop in Nancy. Vallin was an admirer of Viollet-le-Duc, that great champion of the Gothic style, and indeed, there is a suggestion of Gothic architecture in the furniture forms of Vallin's design. The museum in Nancy possesses a dining room designed by Vallin which is typically Art Nouveau. It is also one of the few room ensembles remaining intact from this period. Vallin's furniture is notable for the bulk and power of its line, and the swelling rhythms of the forms, which recall the growth of plant life.

While not of Nancy, René Lalique (1860–1945), the outstanding French jewelry designer of the period, had an aesthetic that was very similar to that of Gallé. Lalique studied in Paris, and by 1885, he had established his own jewelry workshop there. Like Gallé, he drew inspiration from Symbolist poetry, as well as from the style and motifs of Japanese art. Lalique contributed to a whole shift in taste in jewelry—instead of the heavy, diamond-based pieces that had been popular ever since the South African mines had opened, he favored using colored precious and semi-precious stones and even carved glass. He worked gold and silver into fanciful, linear, asymmetrical forms resembling plants, flower, and insects. The small scale of jewelry allowed Lalique a freedom of expression and innovation not possible in other media; thus the element of fantasy triumphed in his

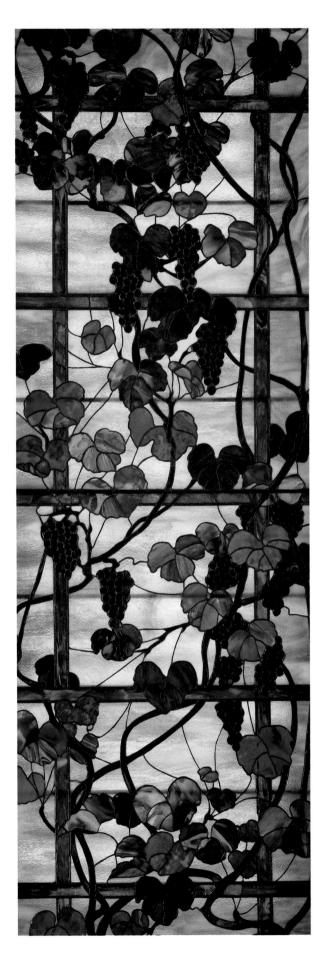

work. He transformed images of women into butterflies or dragonflies, while forming orchids, poppies, thistles, snakes, jellyfish, octopi, bats, and owls out of metal and ornamenting them with unusual gems, such as opals or baroque pearls.

Louis Comfort Tiffany

Art Nouveau in the United States never coalesced into a national school or movement as it did in England and on the European continent. Rather, it was the product of the artistic expression of strong individuals of the period, notably Louis Comfort Tiffany and Louis Sullivan.

Louis Comfort Tiffany (1848–1933) was indisputably the most original and influential artist of Art Nouveau in the United States, and among the greatest in the world. Tiffany was first and foremost a glass artist, and it is in this medium that he excelled and was widely imitated throughout the United States and Europe. Tiffany's father, Charles Lewis Tiffany, was a jeweler and goldsmith, and the wealthy owner of famous jewelry shops in New York, London, and Paris. Louis Comfort Tiffany thus grew up in an atmosphere of craftsmanship, with the resources to travel to Europe and the Middle East, collecting objects that pleased him, including antique glass and Japanese decorative objects.

Tiffany began as a painter of color-rich landscapes, but he was soon entranced with the medieval stained-glass windows of European churches, and, in 1875, he began to experiment with glass himself. Some of Tiffany's most popular stained-glass windows in America were those with landscapes or religious

Grapevine

Louis Comfort Tiffany, c. 1905; stained-glass panel;
98 x 36 in. (248.9 x 91.4 cm). Gift of Ruth and Frank
Stanton, 1978, The Metropolitan Museum of Art, New York.
Tiffany began as a painter of color-rich landscapes, but he was
soon entranced with the medieval stained-glass windows of European churches, and, in 1875, he began to experiment with glass himself. This masterful stained-glass window shows his skillful integration of plant forms into a flat, decorative, semi-abstract pattern.

Wisteria Lamp

Louis Comfort Tiffany, 1892–93; favrile glass and
bronze; height 27 in. (68.6 cm). Private collection.

In 1895, Tiffany began to sell lamps with colorful stained-glass shades, designed to please the eye and mute the unfamiliar brightness of electricity. The shades evoke an abundance of fruit, flowers, or insect life, while the molded bronze bases also contribute to the artistry of the designs, suggesting leaves, stems, or tree roots. Tiffany employed a number of major women designers in his lamp department, including Mrs. Curtis Freschel, who designed the famous Wisteria Lamp, and Clara Driscoll who created the Ivy, Geranium, and Butterfly lamps, among others.

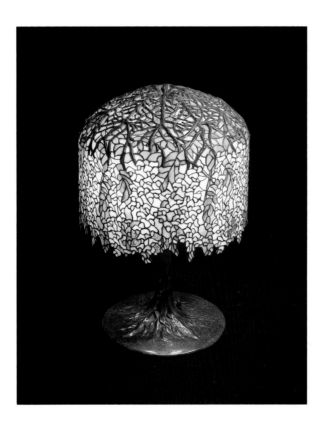

themes. He used his first glass products, iridescent tiles, in the interior decorations his company, Associated Artists, was executing in the homes of the wealthy, including those of Mark Twain and entrepreneur Henry Vanderbilt. He even provided decorations for the White House.

Tiffany's friendship with gallery owner S. Bing led to a commission for ten glass panels based on paintings by French artists Toulouse-Lautrec, Pierre Bonnard, Paul Sérusier, and Edouard Vuillard,

among others, that were exhibited at the opening of Bing's Art-Nouveau gallery. Tiffany's glass panels were remarkable for their flat abstraction and luminous colors, the sinuous lines formed by the lead joining between the panes gave the panels a linear Art-Nouveau quality as well. He was able to recreate the glowing colors of paint with glass pieces that were not of a uniform color, but rather varied within each piece in texture and color.

Between 1893 and 1900 Tiffany produced his most innovative Art-Nouveau work. His use of glass in vases and other decorative objects was known for its iridescence, and for the many unusual techniques which he patented under the name "favrile" glass. He had exhibited twenty of his decorative, favrile glass objects with Bing, who was so impressed with the work that he obtained exclusive European distribution rights for Tiffany's glass. Some of the other techniques Tiffany experimented with include lusterware, agateware, and cypriote, lava, paperweight, cameo, and millefiori glasses. Tiffany favored Art-Nouveau motifs of flowers, plants, and insects. His trademark iridescent glass, produced by exposing hot glass to a series of metallic fumes and oxides, became as synonymous with Art Nouveau as the "whiplash" curve.

Tiffany was also one of the first creators of incandescent lamps in the United States. In 1895, he began to sell lamps with floral motif stained-glass shades and stalk-like bronze bases that softened the harsh new electrical light. His lamps with stained-glass shades became so popular that any lamp of that type became known generically as a Tiffany lamp. Although he celebrated fine craftsmanship, Tiffany, unlike William Morris, was not repulsed by machines and mass production. His Tiffany Studios remained active until 1938, producing all manner of glass decorative and household objects to meet popular demand.

Architects and Designers

Architect Louis Sullivan (1856–1924) was educated both in the United States and Europe (under Frank Furness in Philadelphia and Emile Vaudremer in Paris). Sullivan based himself in Chicago, where he developed a highly individualized form of ornament

with roots in Gothic, Nordic, Celtic, and Greek forms. He was no doubt familiar with Owen Jones's *Grammar of Ornament*, which had appeared in an American edition of 1880, as well as English designer Christopher Dresser's books on ornamentation. Sullivan first applied ornament directly to the surface of his buildings, but gradually his ornamentation softened, curved, and evolved to a more plant-like form, until it became an organic part of his structures. The department store he designed for Carson Pirie Scott & Company in Chicago (1899–1904) employed a luxuriant amount of ornament in relief, as well as subtler surface ornaments. The curling, ornate style of this detail resembles the flamboyance of late Gothic architecture, but it is also undeniably Art Nouveau in its exuberance of curve and line. Interestingly, although the lower floors of the Carson Pirie Scott store are covered with twining, plant-inspired ornament, the upper floors have a smooth facing of stone, with only bands of discrete ornament framing the windows, so that from a distance the building anticipates the plain geometries of modern twentieth-century style.

Less famous than Tiffany or Sullivan, but still important to the Art-Nouveau movement in the United States, was William Bradley, an American graphic designer and typographer born in Boston. After working in printing plants in Michigan and Chicago, Bradley opened his own studio in Chicago in 1893, and the posters and designs he produced there soon won him international acclaim. Although clearly influenced by Aubrey Beardsley, Bradley created a unique Art-Nouveau graphic style of his own. The cover design he produced for the Thanksgiving issue of *The Chap Book* (1895) shows his mastery of elegant, undulating line, flat shape, and asymmetrical patterning. Bradley's style was notable for its simplicity, elegance, and sophistication, and its tone is lighter and more optimistic than Beardsley's vision.

Detail of Ornament: Carson Pirie Scott & Co. Building

Louis Sullivan, 1903–04. Chicago, Illinois.

This Chicago-based architect developed a highly individualized form of ornament with roots in Gothic, Nordic, Celtic, and Greek forms. He was also probably influenced by English Arts and Crafts and Art-Nouveau ideas of ornamentation. The department store he designed for Carson Pirie Scott in Chicago uses twining, plant-inspired ornament on the lower floors, and smooth stone on the upper floors, with discrete bands of ornament around the windows.

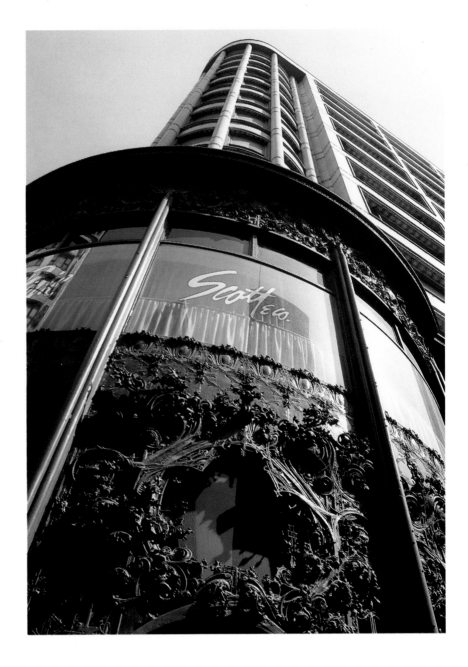

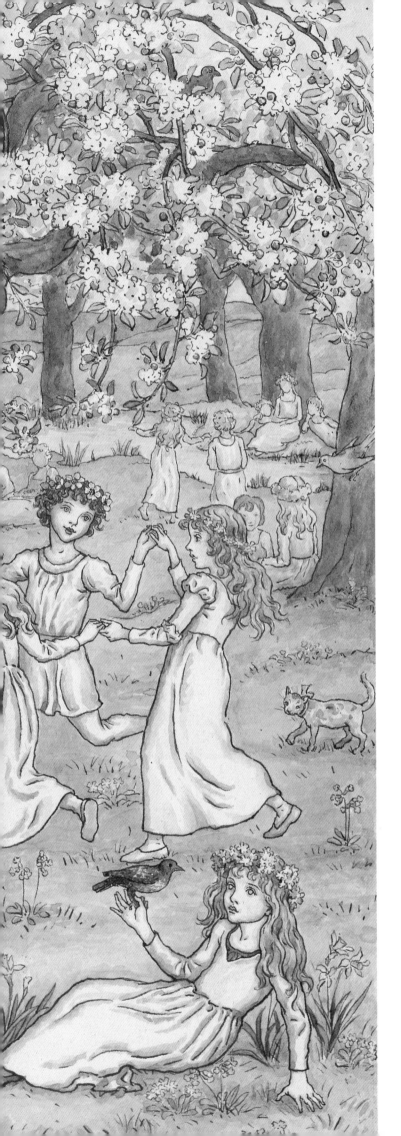

**Frontispiece from
Robert Browning's
*The Pied Piper of Hamelin***

*Kate Greenaway, 1887; book plate.
1957.14, gift of Mrs. George Nichols,
The Pierpont Morgan Library, New York.*
One of the most celebrated children's
illustrators of her time in England,
Greenaway influenced popular taste,
fashion, and manners for several genera-
tions. She uses more traditional space
and line than is typical of Art Nouveau,
but there is a spirit of the style in the
flowing hair and white gowns of the little
children who dance to the Piper's tunes.

57

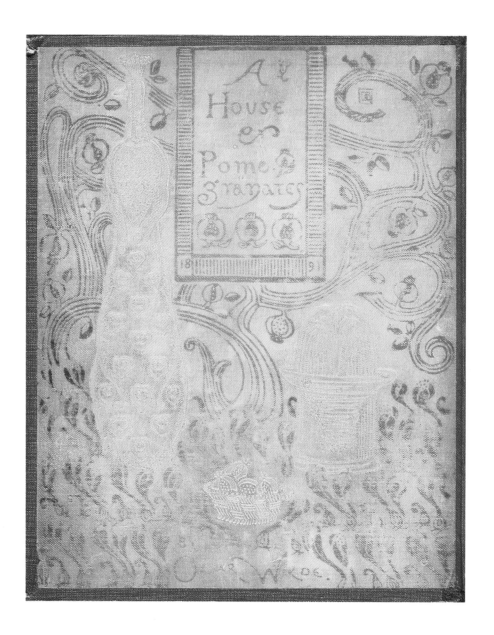

Binding for Oscar Wilde's *A House of Pomegranates*

Charles Ricketts, 1891; stamped linen; 8 1/4 x 7 1/8 in. (21 x 18.1 cm). British Museum, London.
For this book cover, Ricketts created a decorative design with branches of a stylized
pomegranate tree and a carpet of crocus flowers. He overlaid this with the symbols
of a peacock, a bowl of pomegranates, and a fountain. Critics were outraged by the
design, and compared his fountain to an upside-down top hat, but his friend Oscar Wilde
maintained that there were only two people it had to please, himself and Charles Ricketts.

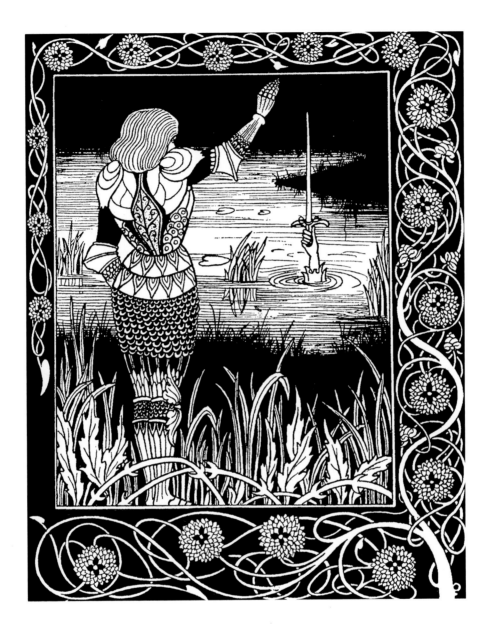

Sir Bedivere with the Sword Excalibur

Aubrey Beardsley, 1893–94; book plate from Sir Thomas Mallory's
Morte d'Arthur. *GNR, Eng, 316, The Pierpont Morgan Library, New York.*

At the conclusion of *Le Morte d'Arthur*, Sir Bedivere casts King Arthur's sword Excalibur into
a lake at his request, and the dying king is carried off into the mists on a magical barge. This
romantic illustration, inspired by the style of Sir Edward Burne-Jones, shows a hand rising from
the lake with Excalibur, signaling that the sword has passed into the spirit plain, as will the king.

Pseudonym, Autonym: Poster for the "Yellow Book"

Aubrey Beardsley, 1895; color lithograph. Stapleton Collection, Great Britain. The flatness, simplification, and curving outlines are all typical of the Art-Nouveau style—here exaggerated for the decorative impression, and the humor imparted to the subject.

Art-Nouveau Designs

René Beauclair; book plate from Dessins d'Ornementation plane en couleurs, *1900. The New York Public Library, Astor, Lenox and Tilden Foundation, New York.* Flat, abstract plant forms have been woven into a variety of elegant patterns in these typically Art-Nouveau designs from a work, which, although less well-known today than *The Grammar of Ornament*, neverless had a wide influence on the world of design.

Embroidered Panel

Unknown artist, c. 1900; tapestry.
Museo Stibbert, Florence.
This beautifully worked embroidery
panel of a vase of flowers illustrates
the spread of Art-Nouveau style and
design beyond the realm of pure
graphic art into commonly practiced
crafts and everyday household objects.

The Chap Book—Thanksgiving Issue

William Bradley, 1895; poster; 20 3/4 x 14 in.
(52.7 x 35.6 cm). The Museum of Modern Art, New York.
The Chap Book was one of the many magazines that spread the influence of
Art Nouveau and showcased the work of its artists. This cover design shows
Bradley's mastery of elegant, undulating line, flat shape, and asymmetrical
patterning—his style is notable for its simplicity, elegance, and sophistication.

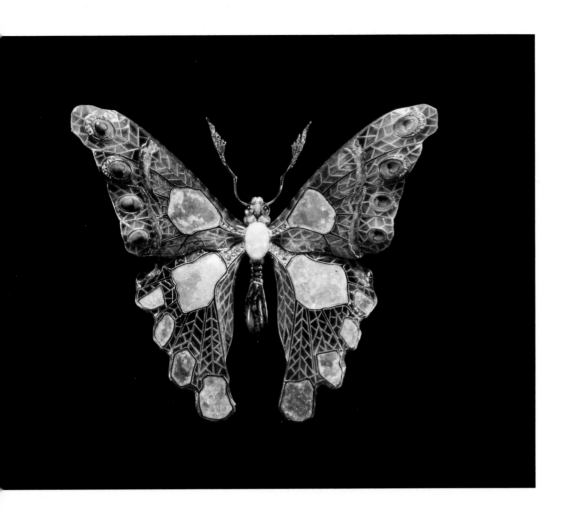

Art Nouveau Jewelry

René Lalique, c. 1900. Anderson Collection of Art Nouveau,
Sainsbury Centre for Visual Arts, University of East Anglia.
Lalique was the unrivaled French jewelry designer of Art Nouveau.
He worked gold and silver into fanciful, linear, asymmetrical forms
resembling plants, flowers, insects, and sea creatures, and he helped
to shift the prevailing taste from heavy, diamond-based pieces to
imaginative, Japanese-inspired jewelry accented with opals, baroque
pearls, and other colorful semi-precious stones. Shown here are
two pieces by Lalique—a dragonfly brooch and a butterfly buckle—
the third piece (above) is by an unknown artist of the period.

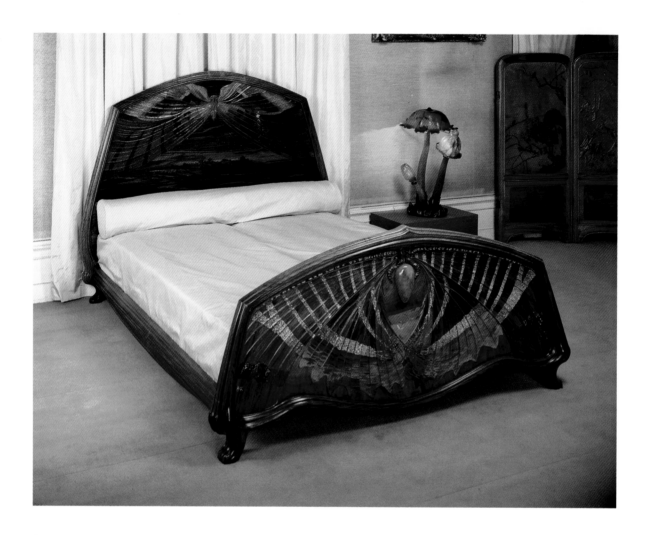

Butterfly Bed

Emile Gallé, 1904; carved opalescent glass, carved fruitwood, and mother-of-pearl. Musée de l'Ecole, Nancy.
In addition to being a master glassmaker, Gallé produced luxury furniture with spectacular
inlay work. This bed was his final creation, and he supervised its construction from his invalid
chair. Fine carving, sumptuous mother-of-pearl inlays, and an iridescent glass inset are used
to evoke the theme of ephemeral day and mysterious night embodied by winged butterflies.

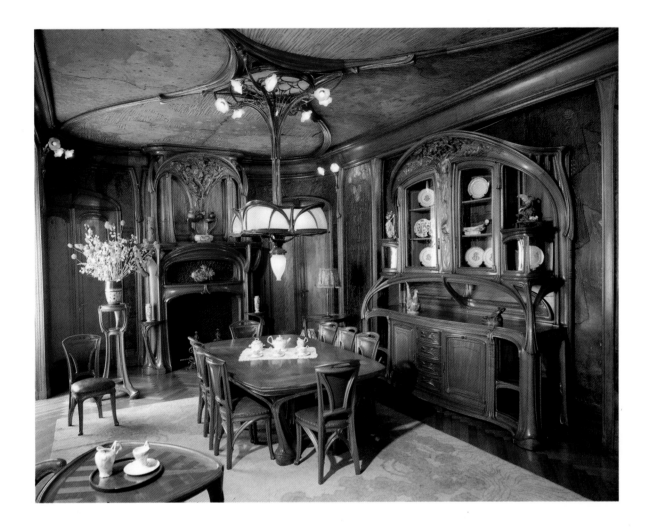

Dining Room

Eugène Vallin, c. 1900; carved wood. Musée de l'Ecole, Nancy.

Vallin was taken on by Emile Gallé to create modern furniture for his workshop in
Nancy. This typical Art-Nouveau dining room ensemble is one of the few complete
rooms remaining intact from this period. Vallin's furniture is notable for the bulk and power
of its line and the swelling rhythms of the forms, suggesting the growth of plant life.

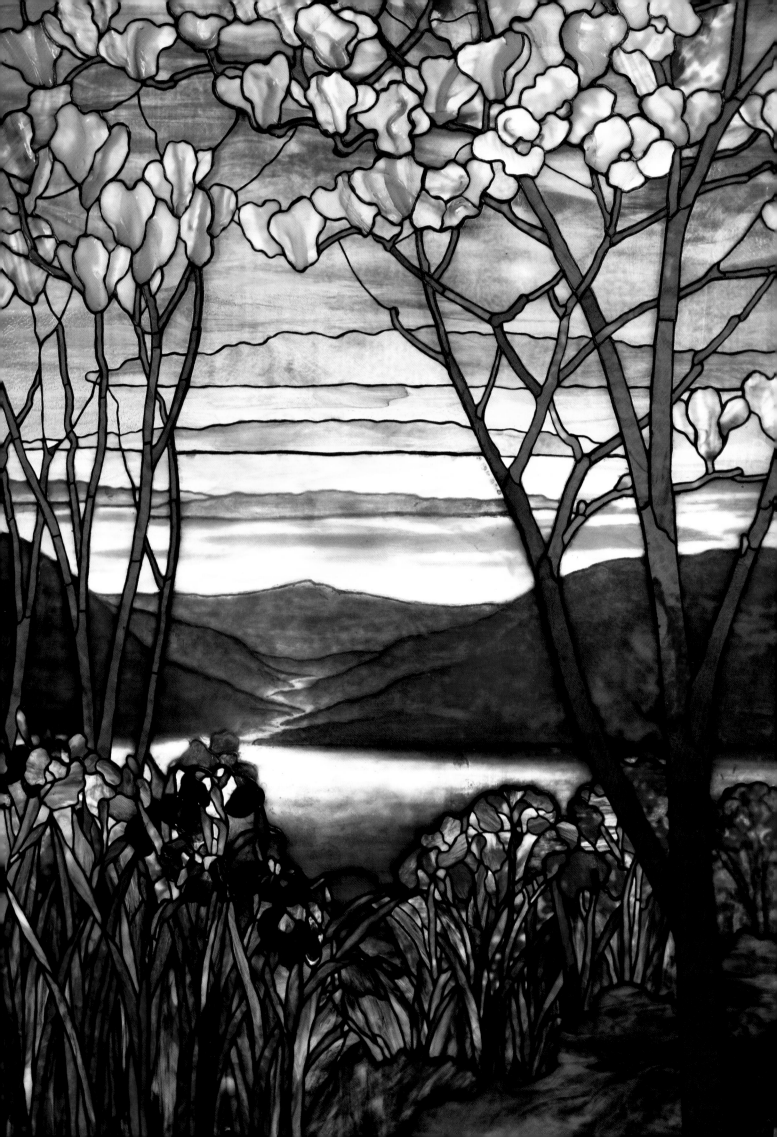

Vase with Cherubim

René Lalique, c. 1900–10; glass.

Musée des Arts Decoratifs, Paris.

In Lalique's hands glass became a means of poetic creation. Lalique also drew inspiration from Symbolist poetry, which influenced his imaginative designs both in glasswork and in jewelry.

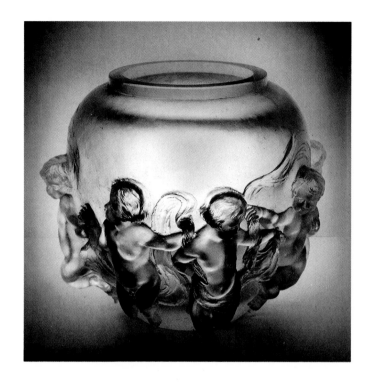

Magnolia and Irises

Louis Comfort Tiffany, c. 1905; leaded-glass window; 60 1/4 x 42 in. (153 x 106.6 cm).

Anonymous gift in memory of Mr. and Mrs. A. B. Frank, The Metropolitan Museum of Art, New York.

Tiffany's stained-glass panels were remarkable for their flat abstraction and luminous colors, the sinuous lines formed by the lead joining between the panes gave the work a linear Art-Nouveau quality as well. He was able to recreate the glowing colors of paint with glass pieces that were not of a uniform color, but rather varied within each piece in texture and color.

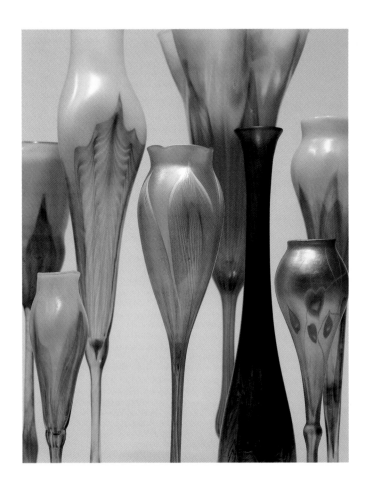

Glasses

Louis Comfort Tiffany, c. 1890; glass. Private collection.

Tiffany was first and foremost a glass artist, and it is in this medium that he excelled and was widely imitated throughout the United States and Europe. Tiffany's patented favrile glass produced painterly colors in individual glass pieces; shown here is a collection of fluted glasses.

Peacock Vase

Louis Comfort Tiffany, before 1896; favrile glass. 1986, gift of H. O. Havemeyer, The Metropolitan Museum of Art, New York.

This innovative American Art-Nouveau glass designer became well known for his luminous use of color. His trademark iridescent creations were produced by exposing hot glass to a series of metallic fumes and oxides—and became as identified with Art Nouveau as the "whiplash curve."

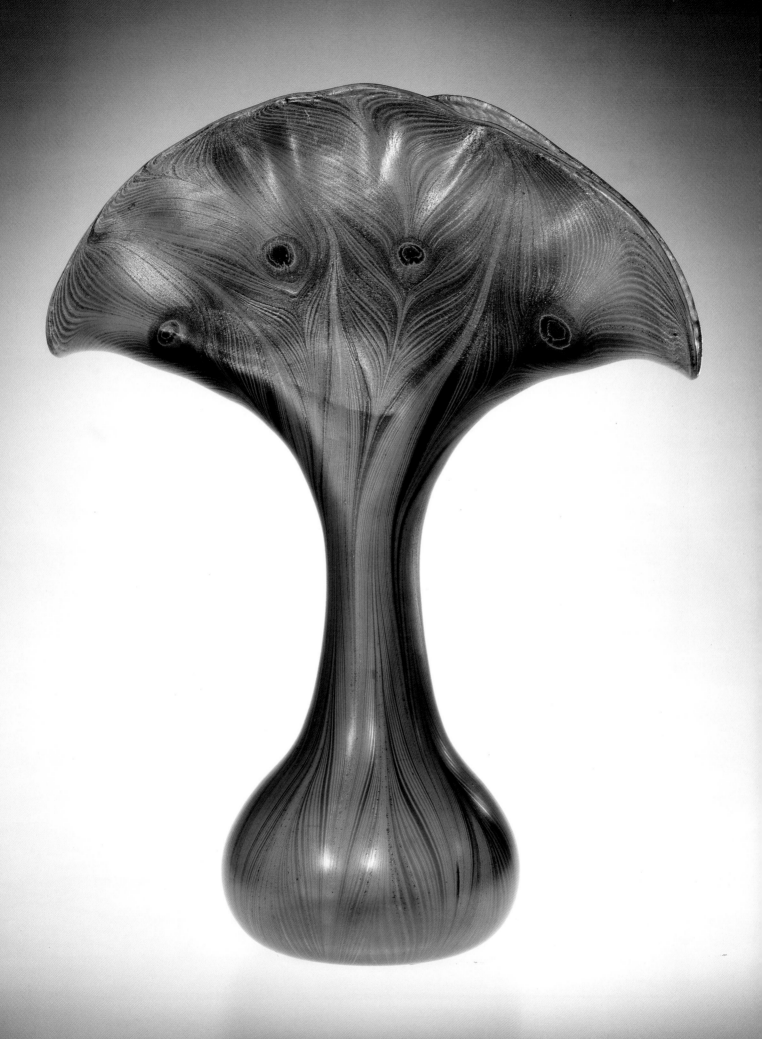

Auti Te Pape (Women at the River)

Paul Gauguin, 1891–93; color woodcut; 8 1/8 x 14 in. (20.5 x 35.6 cm).

Gift of Abby Aldrich Rockefeller, The Museum of Modern Art, New York.

One Tahitian woman suns herself on a river bank while another prepares to dive into the water.
Gauguin left the civilization of Paris to find a simpler life, first in the Brittany region of France, and
later in Tahiti and the Marquesas Islands in the South Pacific. His woodcuts have a rough and rustic
feel that is deliberately cultivated; the work displays the curving, undulating lines of Art Nouveau,
but the intentional "crudeness" of the execution is the opposite of Art Nouveau's elegant sophistication.

AUTI TE PAPE

CHAPTER THREE

A PORTFOLIO OF STYLE

There were many styles and theories present in French painting at the time of Art Nouveau. One group of artists, often called Synthetists or Symbolists, centered around the charismatic figure of Paul Gauguin, who, with his young followers Emile Bernard, Paul Sérusier, and Maurice Denis (among others), lived and worked for a time in the village and vicinity of Pont-Aven in the Brittany region of France. Thus, the work of Gauguin and his followers during the short period from 1888 until 1891, before Gauguin departed for the South Pacific island of Tahiti, has become known as the School of Pont-Aven.

French Painting and Prints

Gauguin and his followers employed many characteristics of Art-Nouveau style in the paintings, graphic works, and decorative objects they produced. According to Robert Schmutzler, Gauguin "was the only great French painter of his time to develop, on his own, a formal idiom that is recognizably Art Nouveau." His style of this period, known as Synthetism or Symbolism, was based on heavy outlines, simplified forms, unconventional color fields, and a sense of flatness and two-dimensionality. Gauguin also favored asymmetry, rhythmic patterns, and arabesques—all characteristics of Art Nouveau. Not surprisingly, Gauguin was interested in many of the same visual sources that inspired Art Nouveau, and also an admirer of the Japanese block prints favored by the Impressionists. Gauguin had, in fact, begun his career in art as an Impressionist under the influence of his good friend Camille Pissarro.

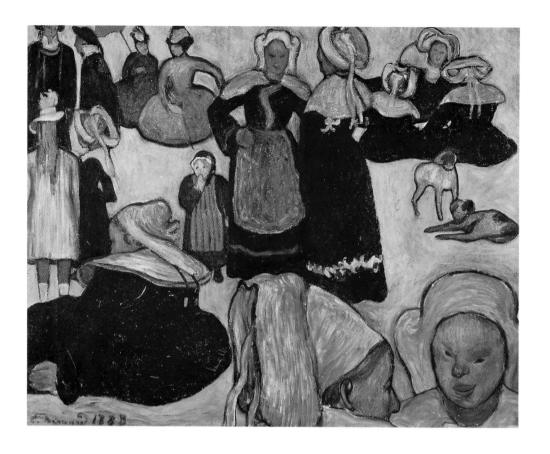

Breton Women in a Green Pasture (The Pardon)

Emile Bernard, 1888; oil on canvas;

29 1/8 x 36 1/4 in. (74 x 92 cm). Private Collection.

Bernard met the charismatic Symbolist painter, Paul Gauguin, in 1888. Under his influence, Bernard began to paint the people of the Brittany region of France pictured here. The region is known for its folk costumes, and these elaborate lace headdresses, starched collars, and embroidered jackets offered intriguing linear possibilities to the artist's eye.

Gauguin had been drawn to Brittany because of the simplicity of life he envisioned there. The rugged landscape had a distinct presence of ancient stone monuments and a folk art with roots in pagan times. The curving forms of the rocks and landscape appealed to the Pont-Aven artists, as did the extravagant curves of the native costumes. In truth, the village of Pont-Aven was not very rustic or remote—it had a busy port and many mills. But all the painters of the Pont-Aven School had a tendency to romanticize the life of the people of the region. They chose to paint agricultural workers in the fields performing everyday tasks while dressed in the lace headdresses, starched collars, and embroidered jackets that were actually only worn on Sundays or festival days. (Conveniently, too, they found life less expensive in Pont-Aven than in Paris.)

Gauguin had a great deal of interest in the applied arts. He admired the Far Eastern enamels, known as *cloisonné*, because of their partitioned technique, as well as medieval sculpture and stained glass. He also admired the folk art of the Brittany region of France, and other cultures he considered to be primitive and exotic. Gauguin carved wooden furniture, and made ceramics and prints in addition to painting. After experimenting with zincography (a lithographic process using zinc plates instead of the traditional limestone), Gauguin found his graphic niche with the woodcut.

Gauguin's woodcuts have a rough and rustic feel that he deliberately cultivated. Their rough-hewn quality differs from the stylish decorativeness of Art Nouveau, which was foremost a style of civilization, not of the primitive and rustic simplicity that he sought after and admired, and would ultimately find in Tahiti and the Marquesas Islands.

Together with Gauguin, Emile Bernard (1868–1941) is considered an originator of the art movements Synthetism and Symbolism. As a young painter, Bernard came under Gauguin's influence when he went to Brittany to paint in 1888, and became very close to him in the period between 1888 and 1892.

Like Gauguin, Bernard had begun by painting in the Impressionist manner, and likewise he became interested in printmaking and experimented with designs of stained glass, embroidered tapestries, and woodcarving. Bernard's pictures show the people of

Brittany and their costumes in a style reminiscent of Gauguin's, but lacking the same power. After traveling to Egypt from 1883 to 1904, Bernard returned to France and developed an academic style. Inexplicably, he spent his later years denying Gauguin's influence.

Paul Sérusier (1865–1927) had begun his career as an academic painter but soon fell under the influence of Gauguin and Bernard, whom he met at Pont-Aven in 1888. As a result of Gauguin's lessons, Sérusier painted a small, colorfully abstract landscape of the forest at Pont-Aven, which became known as *The Talisman*. He brought this painting back to Paris with him, and with it, Gauguin's ideas of pictorial design.

Sérusier began to meet regularly to discuss these ideas with fellow painters Maurice Denis, Edouard Vuillard, and Pierre Bonnard, and the new group called themselves the *Nabis*, after the Hebrew word for prophet. After Gauguin went to Tahiti, Bernard also fell under their influence.

The *Nabis* exhibited together semi-annually throughout the 1890s. Their artistic vision was more "refined" and "citified" than that of their mentor,

April

Maurice Denis, 1892; oil on canvas;

14 3/4 x 24 in. (37.5 x 60.9 cm). Musée d'Orsay, Paris.

This pastoral scene of white-clad women in a field of flowers reveals Denis' interest in the flat patterning and curving lines of Art Nouveau. The abstraction of the design is evident in the way the two women strolling in the foreground appear to have merged into one. The curves of the path, stooping figures, and landscape form the arabesques and counter-rhythms typical of Art-Nouveau style.

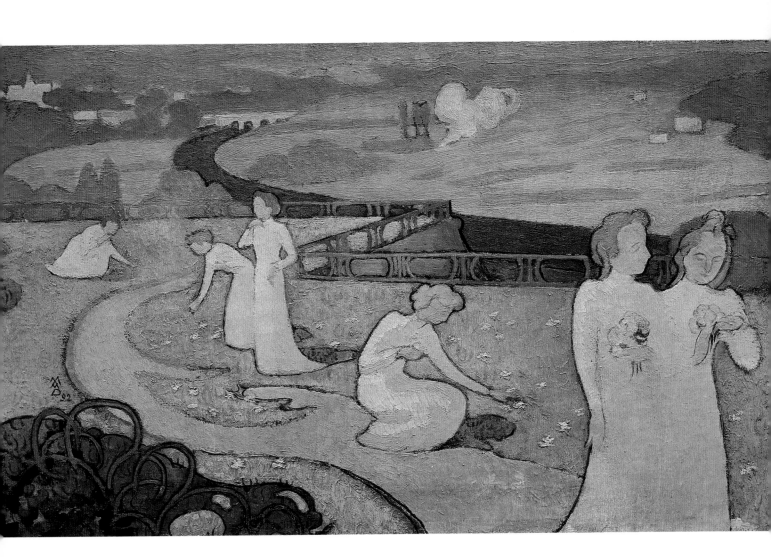

Gauguin, favoring softened colors and a more refined outlook. Their art, which has much of Art-Nouveau style in it, was inspired by Japanese design (there had been a large show of Japanese prints in Paris in 1890), as well as by the art of Puvis de Chavannes and Italian painting of the early Renaissance.

Maurice Denis (1870–1943), another member of the school of Pont-Aven, was also a founding member of the *Nabis*. Denis worked in a wide range of media, including book illustration, printmaking, decorative art, stained glass, theater, and costume design. As can be seen in his painting *April* (1892), Denis' style was Art Nouveau in his use of undulating curves and flattened decorative forms. Denis' writings, for which he is also known, became an important bridge to the twentieth-century styles of Expressionism and Abstraction. He is well known for his assertion that "a picture—before being a battle horse, a female nude or some anecdote—is essentially a flat surface covered with colors assembled in a certain order."

European Painting

The variety of images of women in Art Nouveau is striking in the work of four European painters: Ferdinand Hodler, Jan Toorop, Paula Modersohn-Becker, and Edvard Munch. The work of these painters, as is that of Gauguin and the School of Pont-Aven, is grouped under the general term "Symbolist art." In Symbolist painting, which was closely linked to the Symbolist movement in literature, the essence of a work of art was considered to be in the emotional or spiritual state it represented—that is, how it was felt, not how it was seen.

The art of Swiss painter Ferdinand Hodler (1853–1918) was considered to be the result of his spiritual quest to express his feeling of isolation in the midst of a hostile environment. (Interestingly, Hodler found more acceptance for his painting in France, Germany, and Austria than he did in his native country.) His paintings express a contrast between the commonplace and a mystical order. On a visit to Paris in 1891, Hodler was attracted to the ideas of the Rosicrucians, an esoteric group who believed in the communion of spiritual and physical presences, to whom the *Nabis* were also drawn.

The Art-Nouveau elements of Hodler's style are apparent in his use of patterning and simplification, which creates a rhythmic pattern on the surface of the picture plane. Although his figures were modeled with some weight, he tended to place them parallel to each other in simplified landscapes of stylized flowers. Hodler's images of women were gently spiritual and ethereal, and he interpreted them as either virgininal or Madonna-like.

Dutch artist Jan Toorop (1858–1928) brought Art Nouveau to a peak of expression in his country. Toorop was born on the island of Java in Indonesia, where he spent his early years. His mother was English, and he later spent time in London, as well as Paris and Brussels. In Brussels, he was a member of *The Twenty*, a society and exhibition group that was a rallying point for the French Post-Impressionist movement. Toorop's *The Three Brides* (1893) was reproduced in the first issue of the magazine, *The Studio*, where it was influential as far away as Glasgow and Vienna.

The Three Brides depicts three very different and conflicting images of women. In the center of the picture stands a veiled human bride. To her right is a virginal nun, the bride of Christ, and to her left, the bride of Satan, a personification of the evils of female eroticism. The whole work was conceived as an Art-Nouveau arabesque, as can be seen in Toorop's preparatory drawings. There, and in Toorop's other works, a fetish is made of women's hair, a trait he absorbed from studying the work of the Pre-Raphaelites, but which is also a standard image in Symbolist poetry of the period. Hair, in Toorop's work, frequently had a life of its own. Impossibly long strands—represented by many parallel lines—trail and curve away from the heads of the figures and twine in and out of the composition into framing borders reminiscent of Celtic manuscripts. His sharp-featured, thin-armed female figures are both spooky and mystical, and unlike anything familiar from Western art; indeed, they are derived from the forms of the Javanese shadow puppets of Toorop's youth. Toorop's graphic work owes a debt to Blake, Beardsley, and the spirit of English Art Nouveau; his paintings, in contrast, remain based in a Post-Impressionist style.

The Three Brides

Jan Toorop, 1893; black chalk and pencil; 30 3/4 x 38 1/2 in.
(78.1 x 97.8 cm). Rijksmuseum Kröller-Müller, Otterlo.

This work shows three very different and conflicting images
of women. In the center stands a veiled human bride, to her
right is a virginal nun (the bride of Christ), and to her left, the
bride of Satan, a personification of the evils of female eroticism.
The whole work was conceived as an Art-Nouveau arabesque, as can
be seen in preparatory drawings, and the women's impossibly long
hair has a life of its own, twining and curving all over the picture.

**Design for
La Ferme Cigarettes**
Paula Modersohn-Becker, 1900;
watercolor and ink;
5 1/4 x 6 3/4 in. (13.3 x 16.9 cm).
Kunsthalle Bremen, Bremen.
Two white-clad women play music
in a simple landscape suggested by a
cluster of trees in this Art-Nouveau
design for a cigarette package.
The lettering, flat shapes, and
curving lines give an elegant unity
to this decorative graphic design.

Paula Modersohn-Becker

The images of women in the work of Paula Modersohn-Becker (1876–1907) make an interesting comparison to those of Jan Toorop and Ferdinand Hodler. Modersohn-Becker brought a female perspective to the world of Art Nouveau, a world that was frequently filled with clichéd and stereotypical images of women as either virgins or whores. Modersohn-Becker was a German artist who lived and worked primarily in the small German artists' colony of Worpswede near Bremen. Beginning in 1896, she first studied art in Berlin, and then in Paris on successive trips in 1900, 1903, 1905, and 1906. Very much connected to the art scene of her day, Modersohn-Becker was a friend of the poet Rainer

Mother and Child
Paula Modersohn-Becker, 1907; oil on canvas;
31 x 23 in. (80 x 59 cm). Museum am Ostwell, Dortmund.
Modersohn-Becker's portraits are notable for the honesty and clarity of her vision. Unlike many Art-Nouveau painters, she did not idealize her subjects. She did, however, flatten and simplify forms, and sometimes used a heavy curving outline. Like Gauguin, whose work she admired, she strove to capture the simple, primitive nature of her subjects.

Maria Rilke, and married the painter Otto Modersohn in 1901. During her visits to Paris, she saw Japanese art and admired Rodin's watercolors and works by Vuillard, Denis, and Bonnard. It is also apparent from her work that she was deeply impressed by Gauguin's style. Unfortunately, Modersohn-Becker's career was cut short by her untimely death from a heart attack shortly after the birth of her first child.

Many of Modersohn-Becker's paintings are self-portraits and images of other women, the young and old of Worpswede who sat for her in her studio. Unlike Gauguin and the painters of Pont-Aven, she resisted the temptation to idealize the peasants she painted, and her paintings are notable for the honesty and clarity of her vision. Modersohn-Becker's honesty, however, is not devoid of Symbolist tendencies. She clearly showed a desire to convey a spiritual feeling that transcends the content of the subjects. Her flattened, simplified style—with heavy curving outlines, flat colors and an emphasis of the surface of the picture plane—shows Gauguin's influence, as does her Art-Nouveau use of landscape and floral motifs to enhance the surface patterning, and a self-conscious attempt to return to the simple, primitive nature of her subjects.

Edvard Munch

The Art-Nouveau ambivalence toward women is felt perhaps most strongly in the work of Norwegian painter and graphic artist Edvard Munch (1863–1944), whose color lithograph entitled *Madonna* epitomizes it. Munch's *Madonna* was a Symbolist metaphor, a confusing and mystical interpretation of the spirituality of sex and death. An image of the holy Virgin is completely merged with that of the *femme fatale*, whose sexuality is apparent from her bared breasts and long, flowing hair. Red

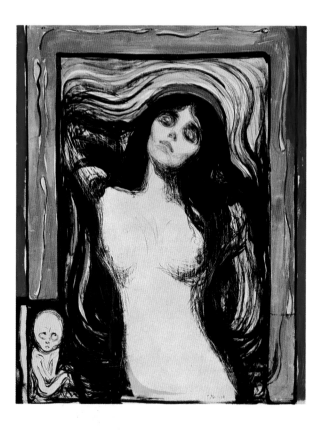

hair, in particular, was a symbol for Munch of the *femme fatale*, derived from his own experience with a would-be seductress. The border of sperm and the skeletal, anxious-looking fetus further dramatizes the sexual message. The *Madonna*'s expression, which could be interpreted as inwardly ecstatic, also has a skull-like aspect accentuated by her cavernous eye sockets and deep nasal shadow.

Munch's style of the 1890s used undulating haloes of lines around the figures and landscapes in an expressive manner that powerfully surpassed the decorative intentions of Art Nouveau. His famous painting of 1893, *The Cry*, shows a person in the throes of an extreme emotional state. Distress and anguish are expressed equally by the intensity of the skull-like face, the gesture of the clutching hands, and the restless lines of the weirdly colored landscape.

Munch was equally skilled as a painter and printmaker. The fluid lines of his woodcuts and other prints were a match for the undulating lines of his brushwork. His work was an important bridge to the Expressionist movement in its tendency to stretch human emotions, in particular sorrow and anxiety, to the limit.

After his initial trip to Paris in 1889, Munch traveled there frequently, where his paintings were exhibited by S. Bing in 1896. He also moved in literary circles in Berlin, and traveled and exhibited in Germany. In 1908, a nervous breakdown signified the end of what was considered Munch's most creative and innovative period of painting, although he continued to rework many of the themes of his early work in his later years.

Madonna

Edvard Munch, 1895; color lithograph; 23 3/4 x 17 1/2 in. (60.3 x 44.5 cm). The Munch Museum, Oslo.

More *femme fatale* than Madonna, this woman's bared breasts and long, twining hair signify sexuality while the skull-like shadows of her eyes and nose represent death. Munch's typically Art-Nouveau ambivalence toward women is apparent in this image, which is a Symbolist metaphor of the spirituality of sex and death. The boarder of sperm and the skeletal, anxious-looking fetus in the lower corner further dramatize his message.

The Cry

Edvard Munch, 1893; oil on cardboard; 33 x 26 1/2 in. (83.8 x 67.3 cm). Nasjonalgalleriet, Oslo.

In this famous painting, Munch has captured the embodiment of an extreme emotional state. Distress and anguish are expressed with equal intensity on the figure's skull-like face, in the gesture of his clutching hands, and the restless lines of the weirdly-colored landscape, which creates a quickly receding perspective simultaneously flattened by sinuous, Art-Nouveau lines.

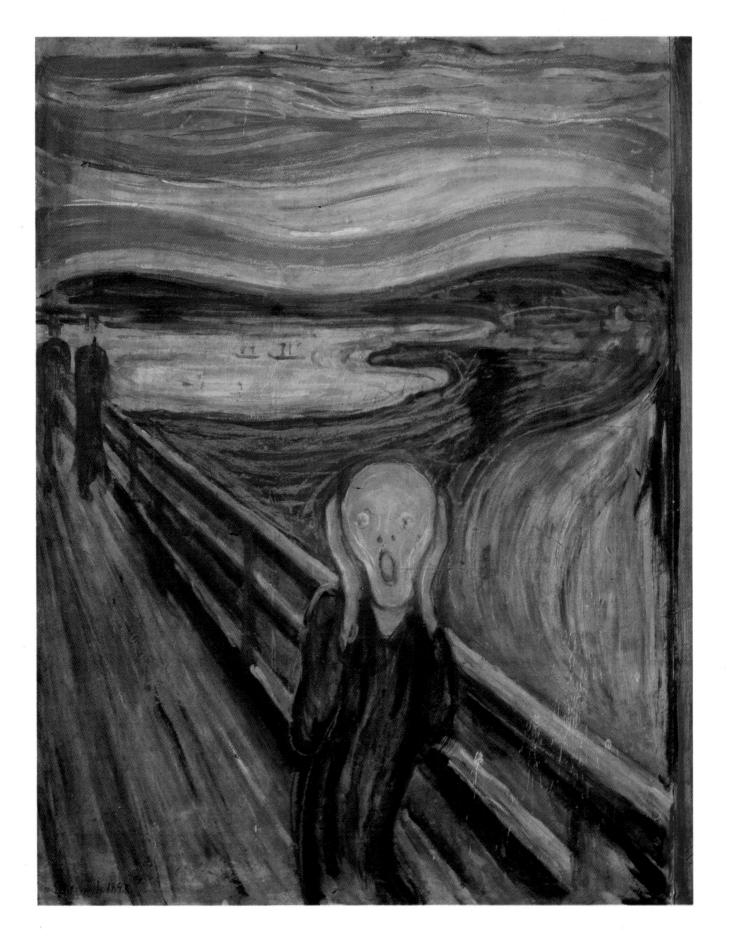

Graphic Expressions

Poster art, by its nature, was an outgoing and cheerful decorative advertising medium intended to catch the eye and create a favorable impression—not to explore deeper spiritual levels of meaning. Poster art in France took an altogether lighter view of women than that illustrated by painters across Europe.

Pierre Bonnard (1867–1947) was a French painter and graphic artist who burst on the scene with his 1891 poster *France—Champagne*. Bonnard used fashionable Art-Nouveau curves to create a light-hearted image of a woman holding a glass of frothy champagne. Her hair, her dress, the overflowing champagne bubbles, and the poster's lettering are all caught up in a exhilarating pattern of curling lines.

Bonnard was foremost a painter of daily life, and he viewed the human comedy with an indulgent eye trained to capture the humorous details of life in action. In his early work of the 1890s, Bonnard saw and drew the world as delineated by Japanese art and the work of Gauguin, whom he knew through his friends Maurice Denis and Paul Sérusier, and to whose *Nabis* group he belonged. His style at that time was characterized by silhouetted shapes, patterns, and arabesques, and he expressed himself in simplified forms, flat colors, and frolicsome lines. Bonnard, in the spirit of Art Nouveau, was active in many areas of decoration: He was a prolific book illustrator, and worked in stage design, stained-glass design, and furniture design, as well. He had a long and prolific career as a painter, though his later style was not Art Nouveau, but rather a type of modified Impressionism, outstanding for its original and jewel-like use of color.

Henri de Toulouse-Lautrec was working as a poster artist in Paris during the same years as Bonnard. Lautrec was also known for a lively sense of line, patterning, and arabesque, as can be seen in his posters *May Milton* and *Le Divan Japonais* (this was the name of a popular cabaret that translates literally as "the Japanese couch"). Unlike Bonnard, Lautrec had a keen eye for the underside of life. He captured the sharp expressions of worldliness in his subjects—the women and men who populated the Parisian world of cabarets, dance halls, and brothels that were his habitual haunts.

The pleasing and decorative posters of Alfons Maria Mucha (1860–1939) were also part of the Art-Nouveau scene in Paris. Mucha was a Czech painter and graphic artist who studied in Germany, Austria, and Paris. He was later active as a book designer and illustrator, and painted murals in theaters and public buildings.

Mucha became famous for his posters of the acclaimed actress, Sarah Bernhardt. Bernhardt was so pleased with Mucha's images of her that she contracted with him to be her official poster artist. As can be seen in Mucha's poster for the Twentieth Exhibition of the *Salon des Cent*, he conformed to the popular poster style of the time, using broad areas of flat color, silhouette, and patterning. Mucha favored a more naturalistic rendering of the human form than either Bonnard or Lautrec, but he exploited the long hair of his model to create the typical, flowing arabesques. Mucha's women seem purely decorative creations, their idealized, sometimes bare-breasted forms merely an attractive advertising display, devoid of any individuality.

Twentieth Exhibition of the Salon des Cent

Alfons Maria Mucha, 1896; lithograph; 25 1/4 x 17 in. (64.1 x 43.2 cm). Musée des Arts Decoratifs, Paris. Mucha conformed to the popular poster style of the time, which used broad areas of flat color and curving lines. The idealized nude model is posed pensively with her chin resting in her hand and eyes downcast. She holds the attributes of an artist's muse in the crook of her arm: a quill pen and a paint brush—as well as an esoteric emblem combining a star, eye, and heart. A shower of stars twinkles at the end of her white veil as her hair cascades freely in impossible Art-Nouveau curls.

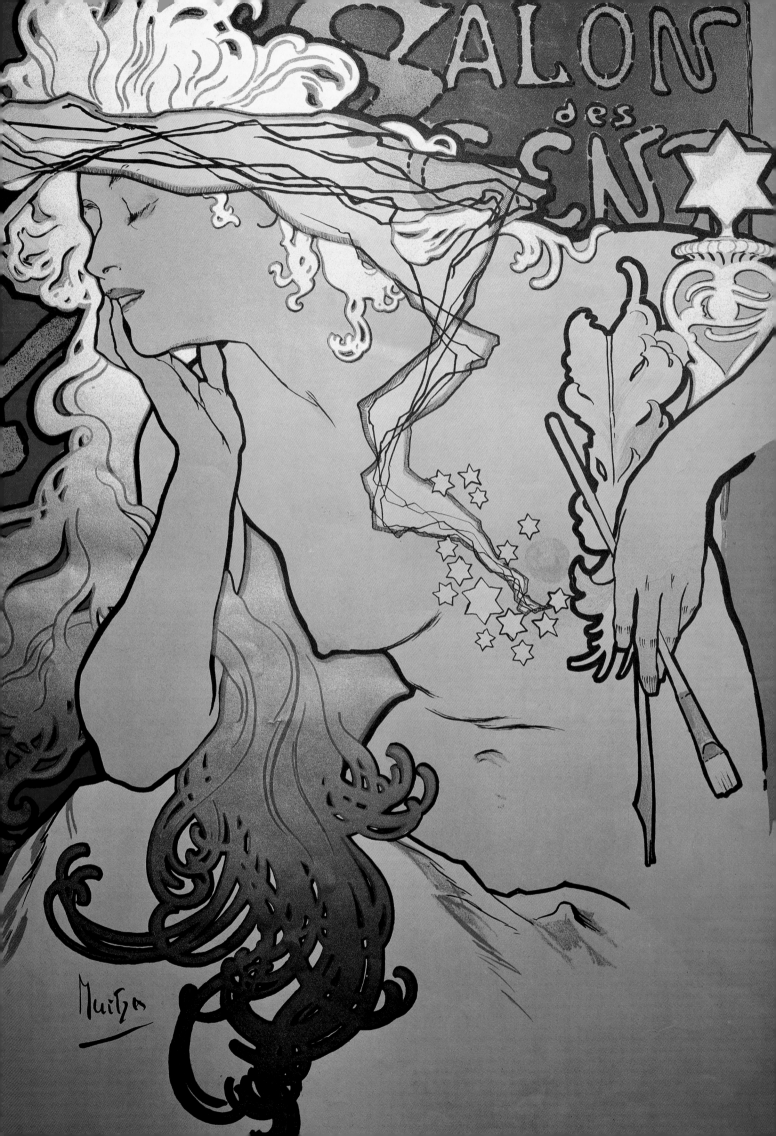

France—Champagne

Pierre Bonnard, 1891; lithograph; 30 1/8 x 23 in.

(76.3 x 58.4 cm). Musée des Arts Decoratifs, Paris.

This poster uses fashionable Art-Nouveau curves to create a lighthearted image of a
woman holding a glass of frothy champagne. Her hair and dress, the overflowing champagne
bubbles, and the poster's lettering are all caught up in a unified pattern of curling lines.

Le Divan Japonais

Henri de Toulouse-Lautrec, 1892, lithograph; 31 5/8 x 23 7/8 in. (79.5 x 59.5 cm). Musée Toulouse-Lautrec, Albi.
This Art-Nouveau poster, with its flat forms and sinuous curves, shows Lautrec's favorite singer
and dancer, the red-haired Jane Avril, accompanied by the literary and music critic, Edouard Dujardin,
at a popular Paris cabaret. Lautrec had been asked to design a poster for the cabaret featuring
the singer, Yvette Guilbert, who is recognizable on the stage by her trademark, long black gloves.

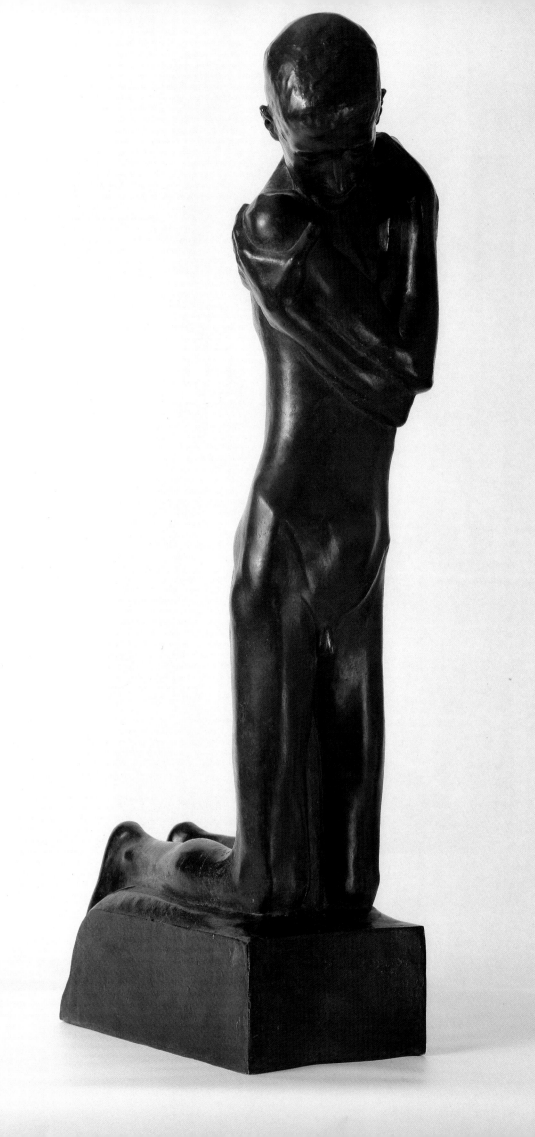

Following page:

Danaïde

Auguste Rodin, 1885; marble; height 12 3/4 in. (32.4 cm.),
length 28 3/4 in. (73 cm). Musée Rodin, Paris.

The graceful lines of the woman's back, neck, and hair emerge smoothly
from the rough stone which gave her birth; stone and body are part of an
organic unity. Rodin, a prolific and influential French sculptor, treated forms
with pronounced fluidity, and excelled at creating smooth curves and volumes.

Sculpture

Art-Nouveau style is more often associated with the graphic and decorative arts than with sculpture, yet certain stylistic trends in sculpture during the Art-Nouveau years—such as a tendency to render form as curving, sinuous shape, and the favoring of closed contours—are discernible. Figures tend to be shown in kneeling, sitting, or hunched postures rather than running or otherwise outwardly extended. While traditional sculptors favored the enduring media of marble and bronze, innovators such as Emile Gallé and Louis Comfort Tiffany explored the sculptural and expressive potential of glass.

In particular, the sculpture of Belgian artist Georges Minne (1866–1941) was notable for the linearity of his forms. Minne concerned himself exclusively with the human form, often kneeling, naked youths, whose forms he exaggerated and elongated, and often used in elegant repetition, as in a fountain he designed with a circle of five kneeling figures. While Minne's figures are somewhat angular, they also have a willowy grace and melancholy languor

that is very much associated with Art Nouveau. Minne was also a good friend of Symbolist writer Maurice Maeterlinck (1862–1949), whose work he illustrated.

Minne was much influenced by the work of one of the great French sculptors, Auguste Rodin (1840–1917), whose treatment of form has a pronounced fluidity, a refined treatment of smooth curves and volumes. Rodin's human forms of this period, both male and female, are often partially imbedded in the rough stone from which they emerge, and both stone and body are part of an organic unity. His watercolor sketches are also notable for their free and elegant fluidity, which caught the eye of many twentieth-century artists. While Rodin's impressive body of work is too vast to be defined by any movement, he certainly partook of the spirit of his time. Much sculpture at the turn of the nineteenth century was united by themes that focused on inward feelings such as sadness, mourning, and despair, and many of Rodin's sculptures had these characteristics. Both Rodin and Minne were represented at the opening show of Bing's Art-Nouveau Gallery in Paris.

The French sculptor Pierre Roche (1855–1922) is best known for his statues and portrait heads of the popular American dancer, Loïe Fuller, whose unique dance lent itself so well to the arabesques of Art-Nouveau interpretation. Roche skillfully captured the flowing curves of her act, which seemed to transform her into an exotic, winged insect or a flickering flame.

Kneeling Boy at the Fountain

Georges Minne, 1898; bronze; height 30 3/4 in.
(78.1 cm). Musée des Beaux-Arts, Ghent.

This Belgian sculptor concerned himself exclusively with the human form—often kneeling naked youths, whose forms he exaggerated and elongated. While Minne's figures are somewhat angular, they also have a willowy grace of form and melancholy languor of mood that is very much associated with Art Nouveau.

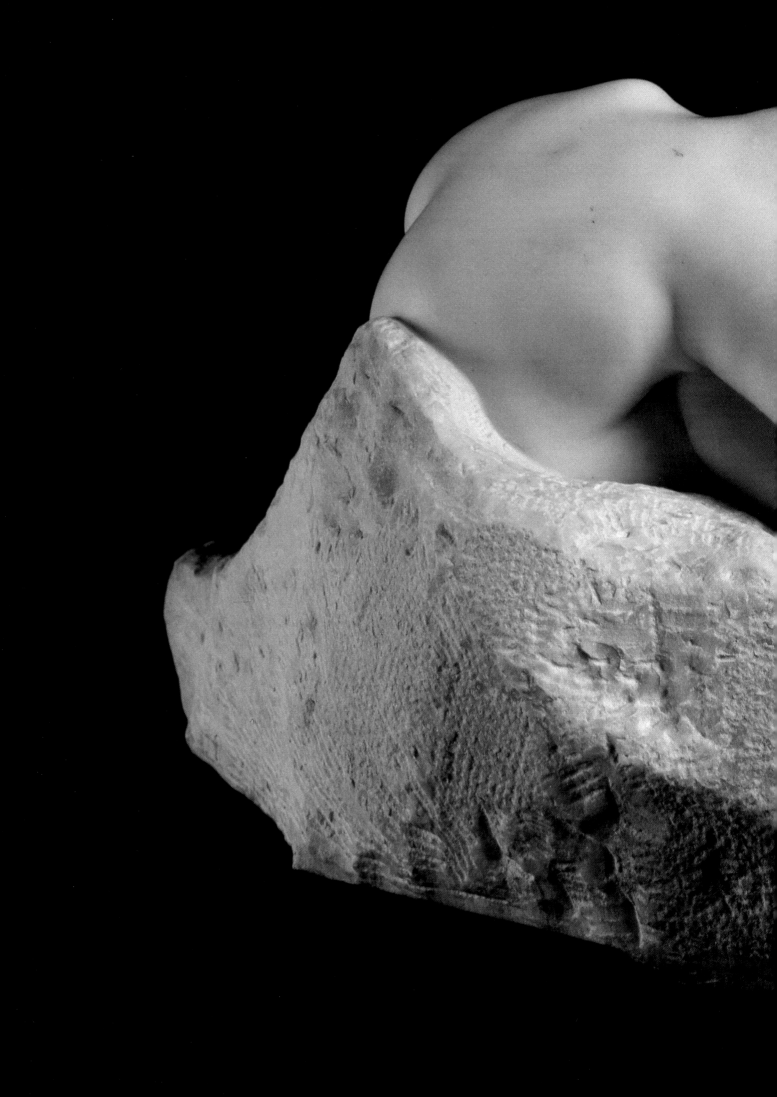

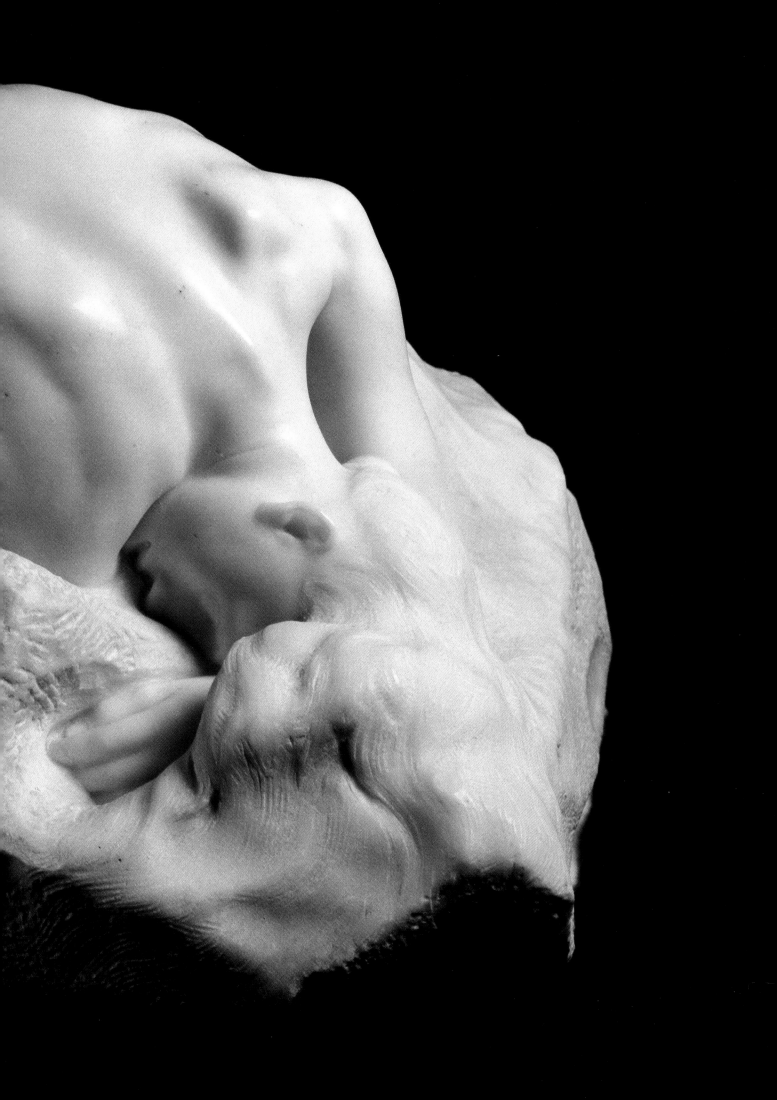

Melancholia (Eve Bretonne)

Paul Sérusier, c. 1890; oil on canvas; 27 1/2 x 36 1/4 in. (57 x 92 cm). Musée d'Orsay, Paris.
A small, nude figure sits dejectedly, head in hand, in an abstracted and flattened landscape.
Sérusier was an admirer of the charismatic painter, Paul Gauguin, whose style he has
absorbed. Symbolist content, such as this evocation of melancholy which puts the
emotion of the painting before its subject, is found among many Art-Nouveau artists.

Still Life with Three Puppies

Paul Gauguin, 1888; oil on wood; 36 1/8 x 24 5/8 in. (91.6 x 62.5 cm).
Mrs. Simon Guggenheim Fund, The Museum of Modern Art, New York.
This unusual still life illustrates Gauguin's Art-Nouveau use of heavy outlines,
simplified forms, and flattening (although his own style was known as Synthetism or
Symbolism). The puppies gathered around their bowl are reduced to simple shapes, and
the head of the one in the middle is echoed in the leaf pattern of the background fabric.

Ashes

Edvard Munch, 1894; oil on canvas; 47 1/2 x 55 1/2 in. (121 x 141 cm). Nasjonalgalleriet, Oslo.
Munch's Art-Nouveau style is apparent in the simple, flattened shapes and curving
lines, as well as in his choice of subject. A long-haired woman clad in white confronts
the viewer with a tortured gaze that seems to hold in equal parts dissolution and despair,
while a dark-clad male figure huddles to one side, his head clutched in his arms.

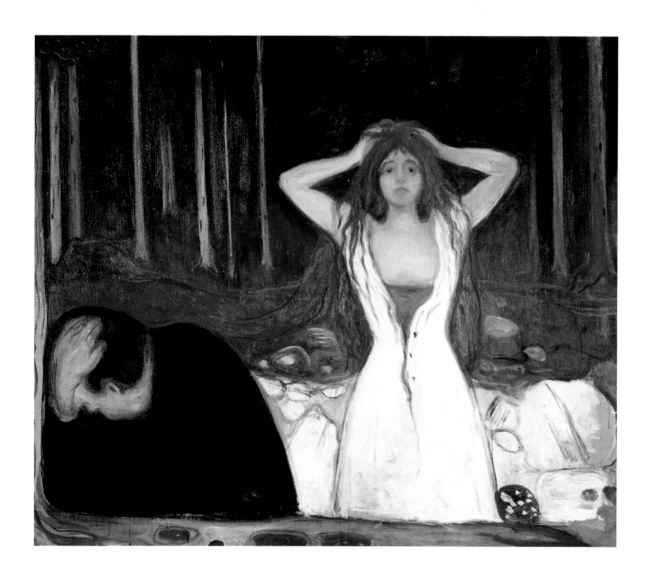

May Milton

Henri de Toulouse-Lautrec, 1895; color-lithographed poster;

31 1/2 x 25 in. (81 x 64 cm). Free Library, Philadelphia.

Lautrec's posters carried the street advertising medium to a peak of artistic expression. At one point his posters became so popular that Parisians actually went around peeling them off the walls before the glue was dry to add them to their personal collections. Here, Lautrec reduces the dress of blond and elegantly shod Parisian cabaret dancer May Milton to an essence of simple, curving lines.

La Revue Blanche

Pierre Bonnard, 1894; lithograph; 30 3/4 x 23 7/8 in. (78.1 x 60.6 cm).

Abby Aldrich Rockefeller Fund, The Museum of Modern Art, New York.

A winking, grimacing boy and a woman dressed in the latest Parisian fashion grace this cover design for a popular Art-Nouveau magazine. Bonnard always retained his ability to capture the element of human comedy in scenes of daily life. Here, his style is Art Nouveau because of the flat, curving silhouettes, and also the way he has incorporated the lettering into a unified design.

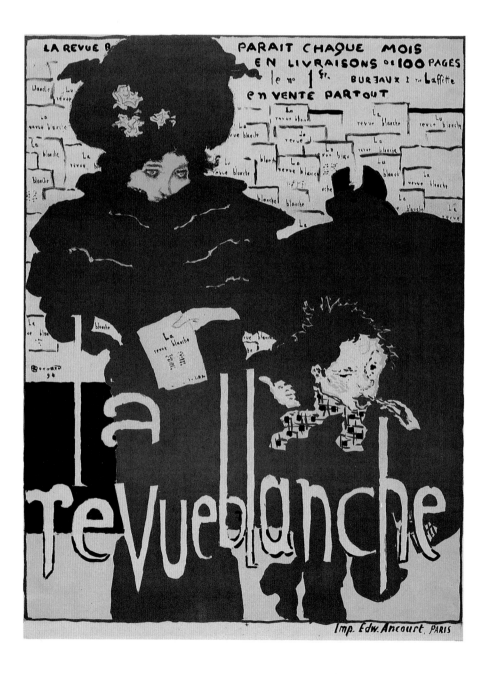

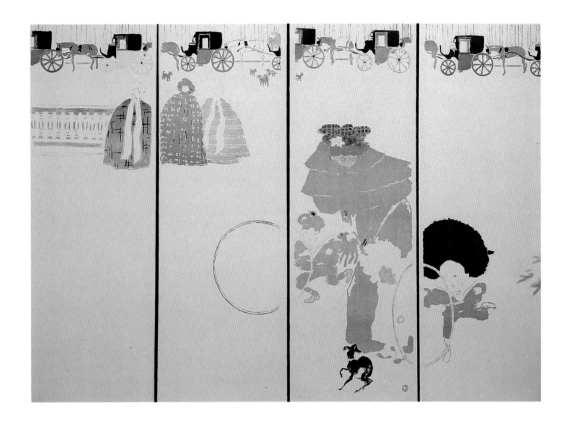

Screen

Pierre Bonnard, 1899; four-color lithograph panels; each panel 53 7/8 x 18 5/8 in.
(136.8 x 47.3 cm). Abby Aldrich Rockefeller Fund, The Museum of Modern Art, New York.
Adopting the flat silhouettes and decorative placement of figures from Japanese art,
Bonnard portrays the details of daily life in Paris with an observant and indulgent eye.
Children with hoops and small dogs scamper and play under the watchful gaze of
their well-dressed guardians, while a line of well-appointed carriages waits in the distance.

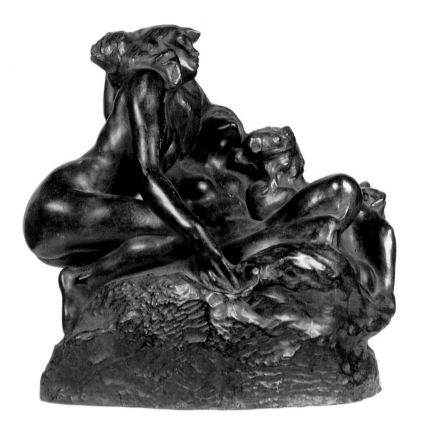

The Sirens

Auguste Rodin, 1889; bronze; height 17 in. (43.2 cm). In memory of
Ralph King: Gift of Mrs. Ralph King, Ralph T. Woods, Charles G. King,
and Frances King, 1946.350, The Cleveland Museum of Art, Cleveland, Ohio.
The Sirens were three sea nymphs of Greek mythology who inhabited
an island surrounded by dangerous rocks, and sang enchantingly to
passing ships, luring them to shipwreck and disaster. Here, the Sirens
are another embodiment of Art Nouveau's evil sexual temptress, the
femme fatale, and Rodin portrays them seductively, with full curves.

Statue of Loïe Fuller

Pierre Roche, before 1900; bronze, height 21 5/8 in. (55 cm). Musée des Arts Decoratifs, Paris.
Roche is best known for his expressive statues of American dancer, Loïe Fuller, whose popular Parisian
cabaret act lent itself to the arabesques of Art-Nouveau interpretation. Here, Roche has captured
the flowing curves of her dance, transforming her into an exotic winged insect or a flickering flame.

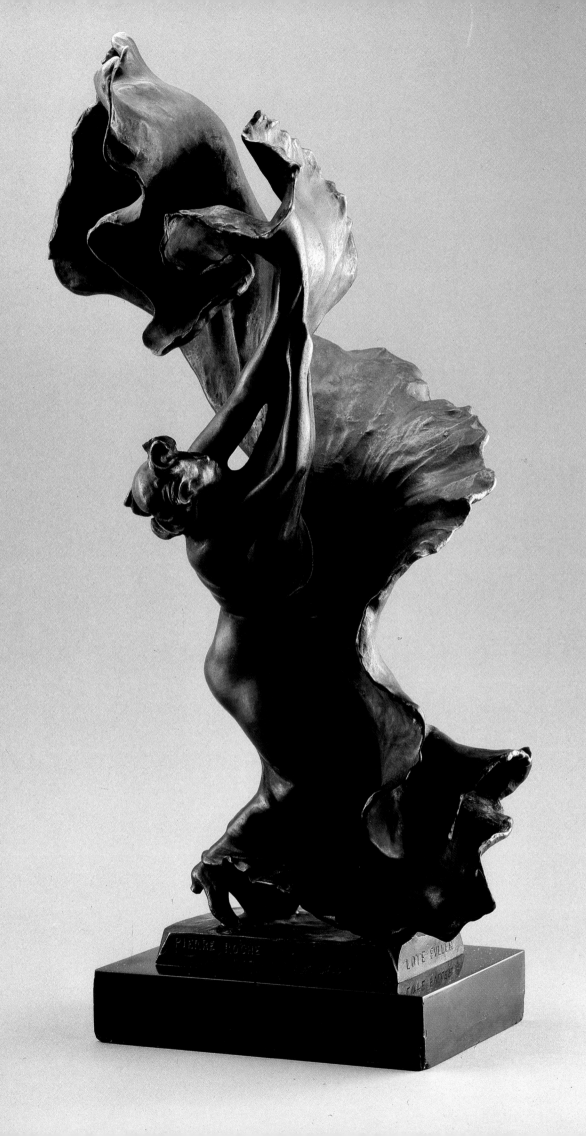

THE WAY TO MODERNITY

Art Nouveau was a far-flung movement with centers in England, France, Vienna and, surprisingly, Scotland. In Scotland, the Art-Nouveau movement centered around Charles Rennie Mackintosh, his wife Margaret Macdonald, and her sister Frances. Together with Frances' husband, the architect J. Herbert MacNair, they became known as the "Glasgow Four," or the Glasgow School. The distinctive style that the Glasgow School contributed to Art Nouveau was characterized by clean geometries of form, combined with curvilinear surface decoration. The buildings, interiors, and furniture produced in the 1890s by Charles Rennie Mackintosh, and frequently decorated by Margaret and Frances, seem to prefigure the rectilinear functionality of twentieth-century Modernism.

Scotland

The sources that interested the Glasgow group were much the same as elsewhere; Japanese style, Blake, the Pre-Raphaelites, Gothic architecture, and the twining patterns of Celtic manuscript art. Jan Toorop's painting, *The Three Brides*, reproduced in *The Studio* in 1893, was probably also influential in the development of the delicate, elongated female figures that the group favored. Perhaps the insularity and isolation of these artists also contributed to their unique interpretation of the Art-Nouveau style.

Charles Rennie Mackintosh (1868–1928) was known as an architect, designer, and watercolorist. He designed, among other things, a number of tea rooms for a certain Miss Cranston; his design responsibilities included every aspect of the interior—

The Moonlit Garden

Frances Macdonald MacNair, 1895–97; pencil with gray and white wash on brown tracing paper; 12 1/2 x 20 1/2 in. (31.8 x 52 cm). Mackintosh Collection, Glasgow University, Glasgow.

A mystical symbolism is the theme of this Glasgow Group artist, who worked and collaborated with her sister and both their husbands. Here, three pairs of gowned women kneel before clusters of tall lilies. The enormous moon behind them sends out rays that contain lines of birds in flight, and the long hair of the women trails to the ground where it takes on new life as a long-stemmed flower.

Facade of the Church of the Sagrada Familia

Antonio Gaudí, 1883–1926, Barcelona.

This church was Gaudí's great unfinished masterpiece—it spans his whole career, and he dedicated the bulk of his later years to it. The building began as a neo-Gothic work, but with time became more fantastic as the ornament grew ever more fanciful. The decoration of the towers is unique and unprecedented— their spires are a twisting, asymmetrical marriage of geometric and organic forms, covered with multicolored mosaics.

the silverware, china, tablecloths, chairs, carpets, leaded-glass decorations, murals, and doors. The doors to the Willow Tea Rooms (1904), for example, show the distinctive style of Mackintosh's open, linear metalwork, which he accented with colored glass. Hill House (1902–93), outside of Glasgow, shows the way he treated an interior as an open, linear network of space. In contrast, his exteriors have a severe modern geometric quality, as evidenced by the facade of the Glasgow School of Art (1899). Mackintosh's poster for the *Scottish Musical Review* (1896) displays the angularity and geometry that

distinguished the Glasgow style in poster art from its French counterparts such as the posters of Lautrec. *The Harvest Moon* (1892), a Mackintosh watercolor, has a mystery and lyricism that also characterized the decorative work of the Glasgow style, a connection to the land of "faerie" that was part of its inspiration.

Margaret Macdonald Mackintosh (1865–1933) and Frances Macdonald MacNair (1874–1921) often worked together as a design team. Among a new generation of women artists who were able to obtain a full art education, they worked as—and considered

themselves to be—professionals. They collaborated on all of Charles Rennie Mackintosh's decorative work, following Margaret's marriage to him in 1900; and they had considerable influence on his style of decoration. The sisters created gesso panels and stained glass in their distinctive style of looping lines, pale colors, and delicate, abstracted figures, as seen in Margaret's *Kysterion's Garden* (c. 1906) and Frances' *The Moonlit Garden* (1895–97). Frances also collaborated with her husband, J. Herbert MacNair, in the design of furniture and stained glass, and taught metalwork at the Glasgow School of Art.

Kysterion's Garden

Margaret Macdonald Mackintosh, c. 1906; pencil and watercolor on brown tracing paper; 11 1/2 x 32 1/2 in. (28.8 x 83.5 cm). Mackintosh Collection, Glasgow University, Glasgow.

Looping lines, pale colors, and delicate abstracted figures characterize the unique Art-Nouveau style of this Glasgow Group artist. The long strands of hair are extended and woven into ornamental patterns that recall the intricate lacing designs of Celtic illuminated manuscripts.

Austria and Germany

The clean geometries of the Glasgow style had a decisive impact on the direction of Art Nouveau in Austria and Germany. Art Nouveau of the Vienna "Secession," while still rooted in a decorative style, was already in flux toward the plain geometries of Modernism. Similarly, the Art Nouveau of Germany, which was known by the term *Jugendstil* ("youthful style"), was quickly leaving the nineteenth century behind and moving toward Modernism.

The Vienna Secession style of Art Nouveau in Austria—as seen in the architecture of Josef Hoffmann, the design of Joseph Maria Olbrich, and the paintings of Gustav Klimt—was also defined by the geometries of the circle, square, and rectangle. In 1897, the Vienna Secession, Austria's Art-Nouveau movement, attempted to shake up and reform the conservatism of Viennese society. The magazine that spread word of the new movement was called *Ver Sacrum*, a Latin reference to pagan sacred rites of spring, which continued the theme of newness and rebirth for the new style. Secessionist Josef Hoffmann was a man of many talents—an architect, graphic artist, and designer—as well as an influential teacher. In 1903 he also helped found the Vienna Workshops, which were dedicated to advance the Austrian contribution in the applied arts. Gustav Klimt was the first president of the Vienna Secession and also collaborated with the Vienna Workshops.

A fine example of late Art-Nouveau architecture is the Stoclet Palace, a mansion designed by Josef Hoffmann (1870–1955) for the wealthy industrialist and art patron, Baron Stoclet of Brussels. Hoffmann based the building on rectangular forms, not the curves of earlier Art Nouveau. The sole exterior decoration is formed of white marble slabs framed with a gold frieze to highlight the elegant, linear structure. Hoffmann designed every aspect of the Stoclet Palace and its furnishings, including the landscape gardening and the silver wall sconces. The walls of the spectacular dining room were decorated by Gustav Klimt and inlaid with a costly mosaic of marble, metal, colored glass, enamel, and semi-precious stones. Klimt's designs, rivaling the splendor of Byzantine mosaics, essentially transformed the human figure into ornament—while keeping the faces and hands naturalistic.

In *Fulfillment* (1905–09), one of Klimt's preparatory designs for the Stoclet frieze, an embracing couple is abstracted into a flattened pattern of spirals, swirls, squares, and triangles. An abstract eye motif in the background was borrowed from Egyptian art—one of the many exotic elements in Klimt's uniquely personal Art-Nouveau style.

Klimt was an internationally famous painter. His portraits combined a skillful naturalistic rendering of faces and hands with a distinctive vocabulary of abstract ornament characterized by repeated geometric forms, often heavily applied in gold and silver. Klimt was also attracted to popular Art-Nouveau themes such as the evil sexual temptress, and the ages of man (including women), which were also popular

Poster for the
First Exhibition of the "Secession"
Gustav Klimt, 1897; color lithograph.
Historiches Museum der Stadt Wien, Vienna.
Klimt's famous poster for the "Secession"—the new artists' group that seceded from the Kuenslerhaus artists in 1897—was censored by the authorities. The second print run had trees covering Theseus' genitals in the top panel, which illustrates Theseus slaying the Minotaur.

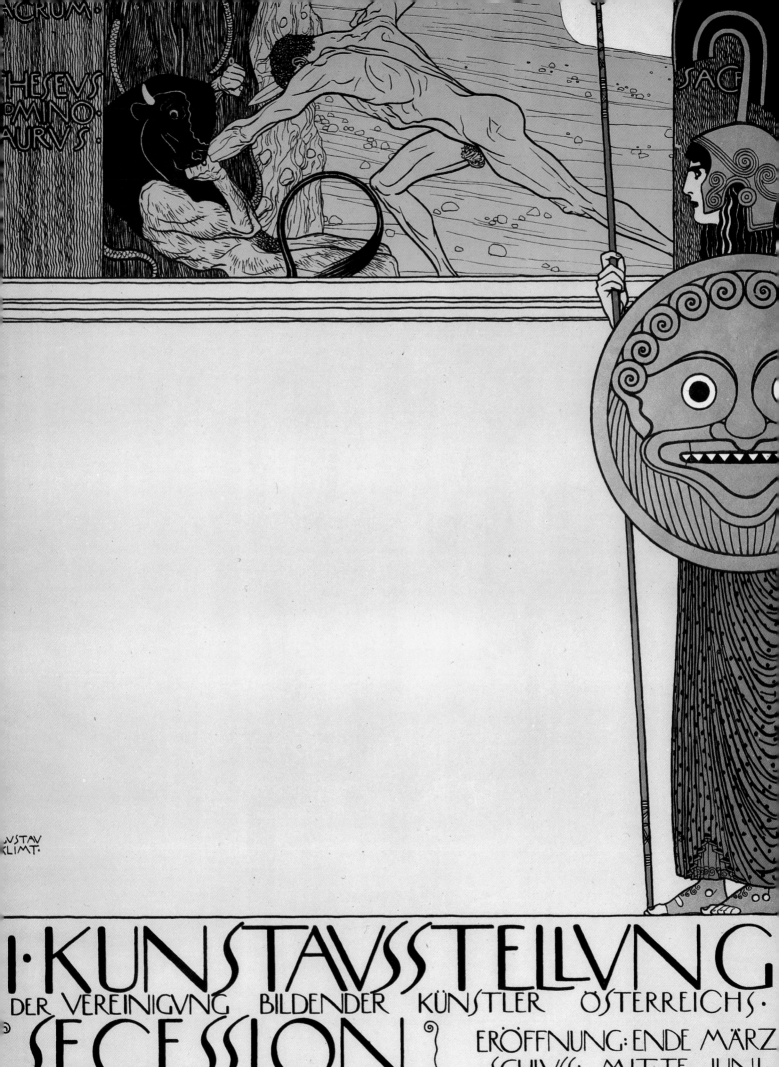

I·KUNSTAVSSTELLVNG
DER VEREINIGVNG BILDENDER KÜNSTLER ÖSTERREICHS·
SECESSION

ERÖFFNUNG·ENDE MÄRZ
SCHLVSS: MITTE JUNI·

I·PARCRING·12·
GEBÄUDE DER K·K· GARTINBAU GESELLSCHAFT

with Edvard Munch and Aubrey Beardsley. Klimt's well-known painting, *The Kiss* (1907–08), is a decorative and sensitive rendering of this erotic theme that also preoccupied Munch. The merging of the forms of the lovers into one body is characteristic of the Art-Nouveau treatment of this subject.

Another leader of the Vienna Secession was Joseph Maria Olbrich (1867–1908), an Austrian architect, draftsman, and designer. Olbrich studied with the great Austrian architect, Otto Wagner, and began his career as an illustrator. He designed the Secession building and many buildings in Darmstadt for the Grand-Duke of Hesse, as well as rooms for the 1900 Paris Exhibition and the 1902 Turin Exhibition.

Olbrich's candelabrum (c. 1900) shows that he had abandoned curves and flowers in favor of clean-cut form. His many designs for typographic ornaments, jewelry, and fabrics clearly show his tendency to stylize natural forms until they gradually become unrecognizable. In this candle holder, characteristic of his later style, he is reacting against Art-Nouveau fantasy, while still retaining a linear elegance of form and a love of materials typical of the style.

Kolomon Moser (1868–1918), another Austrian painter, designer, graphic artist, and founding member of the Vienna Secession, was also an influential

The Kiss

Gustav Klimt, 1907–08; oil on canvas; 70 7/8 x 70 7/8 in.
(180 x 180 cm). Kunsthistorisches Museum, Vienna.

This square painting of embracing lovers makes an interesting comparison to the couple Klimt painted in *Fulfillment*. The clothing of the couple, the field of flowers where they kneel, and the gold-flecked background are painted as flat, decorative Art-Nouveau pattern, while their hands and faces are modeled naturalistically.

sit...

force in the Austrian applied art movement. His lithograph for a religious calendar of 1898 is a good example of his flattened, elegantly linear graphic style: A hooded figure is seen in profile holding an hourglass, her face framed by a few twining strands of hair and a bunch of flowers so abstracted they appear to be a cluster of simple circles.

The Art Nouveau, or *Jugendstil*, period in Germany was centered in the city of Munich. *Jugendstil* artists of the 1890s felt a moral responsibility to create objects of fine workmanship to counter the output of shoddy, mass-produced goods that were flooding the marketplace. Much in the way the Arts and Crafts movement had galvanized artists in England, applied arts and fine workmanship became of central importance to many German artists of the period, including Peter Behrens, Otto Eckmann, August Endell, Herman Obrist, Bernhard Pankok, and Richard Riemerschmid.

Peter Behrens (1869–1940) was an architect and designer most famous for his design for the turbine factory he build for A.E.G., the German electrical combine in Berlin. This building of 1909 was considered to be a pioneering example of modern construction in glass and steel. Behrens' style as a graphic artist can be seen in his color woodcut of 1898, *The Kiss*, where he treated a popular Art-Nouveau subject in a cool manner. Framed by the dense arabesque of their intertwined hair, the two lovers' lips come together in a formal manner that betrays little passion. Their passion is expressed only symbolically—by the union of their hair.

Two-Armed Candelabrum

Joseph Maria Olbrich, 1901; pewter; height 14 1/4 in. (36.2 cm).
The Philip Johnson Fund, The Museum of Modern Art, New York.
This elegant late Art-Nouveau candelabrum shows that Olbrich had abandoned curves and flowers in favor of clean-cut form. Olbrich had a tendency to stylize natural forms until they gradually became unrecognizable. In this two-armed candlestick, he is reacting against Art-Nouveau fantasy, while still retaining a linear elegance of form and a love of materials typical of the style.

The Kiss

Peter Behrens, 1898; color woodcut; 10 5/8 x 8 1/2 in. (27 x 21.6 cm).
Gift of Peter H. Deitsch, The Museum of Modern Art, New York.
Framed by a dense Art-Nouveau arabesque of hair, these lovers' lips come together in a cool manner, and their passion is expressed abstractly by the twining strands of their hair. Art-Nouveau artists frequently depicted loving couples completely merged in an embrace, but Behrens shows these androgynous lovers joined only symbolically—through the union of their tresses.

Tropon

Henry van de Velde, 1899;
poster; offset facsimile of
original lithograph;
31 5/8 x 21 3/8 in.
(80.3 x 54.3 cm). Gift of
Tropon-Werke, The Museum
of Modern Art, New York.

In this most abstract of
all Art-Nouveau posters
Van de Velde is almost true
to his principle that orna-
ment should have no natu-
ralistic association. Tropon,
"the most concentrated
nourishment," is advertised
with curving plant forms
that represent only the
most abstract idea of
nourishment and growth.
The lettering of the
poster is fully incorporated
into the linear design.

The style of architect and designer Richard Riemerschmid (1868–1957) was both simple and functional, as is evident in this chair he designed in 1899. Riemerschmid rejected ornament completely in favor of a simple, linear style that combines both the curves and the geometries of Art Nouveau.

Russian painter and printmaker Wassily Kandinsky (1866–1944) was living and working in Munich during the *Jugendstil* period. His romantic woodcuts of this era are based on medieval fairy tales: *Farewell* (1903), illustrates the flat, decorative, linear style and subdued color Kandinsky used during this period. His poster for the first Phalanx exhibition (1901) shows his rounding of forms and tendency to make them ever more abstract and symbolic.

Kandinsky's *Jugendstil* period was only the starting point of his career as a painter. He became known as one of the pioneering abstract painters of the twentieth century, and his ever more abstract and symbolic forms gradually dissolved into bright washes of color and line, where the subject was no longer the point of the picture, or even a recognizable motif.

Kandinsky was as famous for his writings as for his art. His book, *Concerning the Spiritual in Art* (1911), was a pioneering document of the early modern period that called for a complete break with art of the past and a search for inner meaning if art is to regain "her soul." Kandinsky called for removing all natural representation from art—for only through breaking from nature, he said, could art free itself from being mere decoration "suited to neckties or carpets." Kandinsky's words brought art into the twentieth century—in a true revolt against his Art-Nouveau origins.

In contrast to Kandinsky, the Belgian Henry van de Velde and other pioneers of Art Nouveau had called for an art of decoration where neckties and carpets would be equal to painting. Van de Velde had described an ideal room where "every one of the objects in it testifies to the common intent to bring about a single emotional effect." The pioneers of Art Nouveau were true to this call, and succeeded in making Art Nouveau an all-encompassing decorative moment. On the other hand, van de Velde's

assertion that ornament should have no "naturalistic association" shows that Kandinsky's idea of "breaking with nature" was already present in Art-Nouveau theory.

Van de Velde's Tropon poster of 1899 is one of the most abstract posters in all of Art Nouveau. It advertises its product, "Tropon—the most concentrated nourishment," with curving plant forms that represent only the most conceptual idea of nourishment and growth.

Side Chair

Richard Riemerschmid, 1899; mahogany with leather seat; height 31 1/2 in. (80 cm). Gift of Liberty & Co., Ltd, London, The Museum of Modern Art, New York.

Riemerschmid's distinctive style, which is both simple and functional, is evident in this chair. He has rejected ornament completely in favor of a simple, linear style that combines both the curves and the geometries of Art Nouveau. This chair already has the "modern" look that succeeded Art Nouveau.

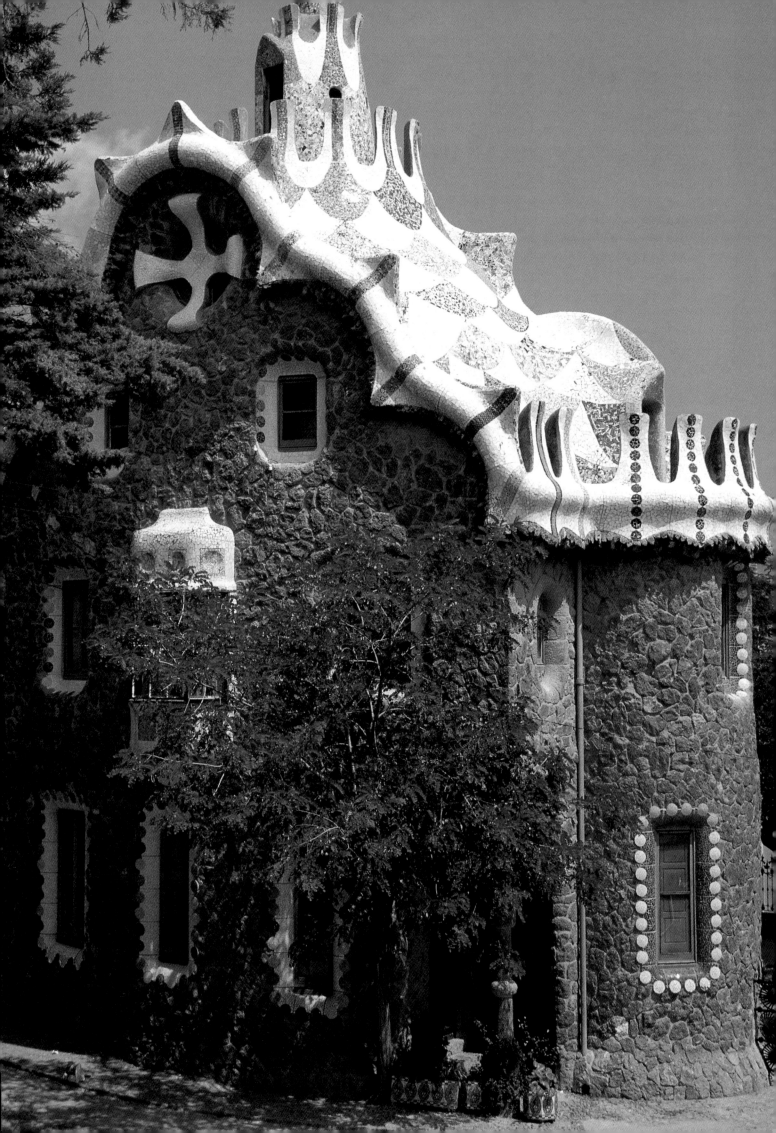

Spain

The unsurpassed creative genius of Art Nouveau in Spain was Antonio Gaudí (1852–1926). The Art-Nouveau movement in Spain, which continued later than elsewhere (ending only with Gaudí's death in 1926), was centered in Barcelona where Gaudí trained and worked. Gaudí created his first Art-Nouveau work in iron, which, because of its versatility, was a favorite material of Art-Nouveau artists. His father was a coppersmith and Gaudí had grown up seeing metal being shaped. Gaudí's exposure to French Art Nouveau most likely came from journals and publications, and he was also influenced by Gothic architecture, the Rococo and the Moorish style of his country.

Gaudí was a craftsman with a genius for materials. The inventiveness of his structures, which transform the shapes of ordinary rooflines into the backs of dragons or other fantastic creatures, are unique in the history of architecture and put an entirely original spin on Art Nouveau. Gaudí's Entrance Pavilion of the Park Güell (1900–14) combines stone, colored mosaics, and ironwork to phantasmagoric effect. Gaudí, who also designed the furniture for some of his buildings, was a master of texture, color, and unconventional, undulating, organic forms. The roof of his apartment building, the Casa Batlló (1905–07) had a roofline that looked like the back of a dragon, balconies like pieces of seaweed, and windows that yawned like the openings of caves. The front of the apartment building Casa Mila (1905–10) was unified by its curving irregularity—with hardly a straight line

in sight. This curving, irregular quality was present not only on the facade but throughout the entire building—in its floorplan, and every aspect of the decoration, including the seaweed-like iron railings.

Gaudí's great, unfinished masterpiece, the Church of the Sagrada Familia (1883–1926) spanned his whole career as an architect, and it was to this building that he dedicated most of his later career. The building began as a neo-Gothic work, but, as time went on, became more fantastic and its ornamentation even more fanciful. The decoration of the towers is unique and unprecedented—their spires are a twisting, asymmetrical marriage of geometric and organic forms, covered with mosaics in many colors.

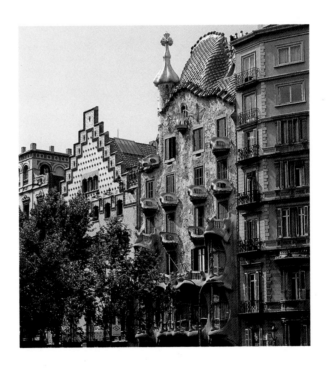

Casa Batlló

Antonio Gaudí, 1905–1907, Barcelona.

Gaudí converted the facade of this existing apartment building on Barcelona's fashionable street, the Paseo de Gracia, into an architectural fantasy. The roofline resembles the back of a dragon with its unusual contours, which achieve the texture of scales and vertebrae through the creative use of tile and stone. The lower windows are divided by columns resembling bones, while the surface of the facade is covered with a mosaic of colored glass in delicate hues. Ribbon-like, wrought-iron balconies and a strange turret crowned with a large flower complete the design.

Entrance Pavilion of the Park Güell

Antonio Gaudí, 1900–14, Barcelona.

Art Nouveau flowered in Spain with the innovative architecture of Gaudí. Influenced by Gothic, Rococo, and Moorish buildings, as well as continental Art Nouveau, Gaudí crowned his Barcelona structures with unusual rooflines formed of undulating curves. In this pavilion, he has combined stone, colored mosaics, and ironwork for the effect—in the eye of the modern viewer—of a Disneyland castle.

The Circus (Le Cirque)

Georges Seurat, 1891; oil on canvas;

73 1/4 x 59 5/8 in. (186 x 151.4 cm). Musée d'Orsay, Paris.

All the excitement of the circus is present in this lively painting—
acrobats leap, a dancer postures on the back of a galloping horse,
a clown grimaces, an animal tamer snaps his whip, musicians play,
and spectators gawk. This painting has the linear arabesques, odd
exaggerations, and strange counter-rhythms and flatness of the Art-
Nouveau style; it also has Seurat's own Pointillist style, a scientific use
of dots of color to create images that earned him his place in the art world.

Endings and Beginnings

The Universal Exposition in Paris in 1900 signaled
both the height and the decline of Art Nouveau.
While the Exposition, which was filled with Art-
Nouveau works, demonstrated that Art Nouveau had
succeeded brilliantly in becoming a popular style, its
very popularity soon led to its decline. The fine work-
manship and originality that had characterized Art
Nouveau from the beginning could no longer be
upheld as its works were mass-produced to meet pop-
ular demand and its ideals were degraded.

Art Nouveau had served its purpose of inspiring a
new art for a new age. But inevitably, what is new
soon becomes old—and this can happen very fast in
the world of fashion and style. As the world moved
into the new century, Bing, the dealer whose
gallery had given Art Nouveau its name, retired.
Many of the artists who had galvanized the move-
ment died, or moved on to other styles and interests.
Art-Nouveau furniture and objects that had been
considered the height of fashion were tucked away
in attics and forgotten.

Still, the artists of Art Nouveau had paved the
way for the styles of the twentieth century. French
Post-Impressionist painter, Georges Seurat
(1859–91), who produced a few Art-Nouveau works,
such as *The Circus*, (1891) before his premature
death, is but one of many

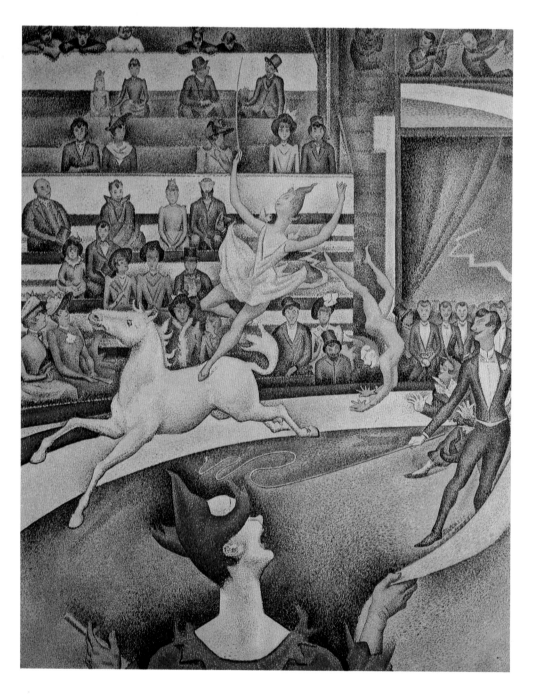

artists who, while only on the fringes of Art Nouveau, made a significant contribution to the evolution of modern painting. Seurat's style is known as Pointillist, because of the scientific system he used employing precise dots of color to create images. *The Circus* has the arabesques, exaggerations, and flatness of Art Nouveau, but it was the unique technique that Seurat had developed which set him apart in the history of art, and was of interest to later generations of artists.

Edouard Vuillard, who also partook of Art-Nouveau style, later moved away from it. Vuillard's works are often dominated by the patterns of wallpaper and textiles, to which he was perhaps more attuned than others—his mother had been a dressmaker, and his uncle designed textiles; pattern was to him second nature.

Maurice Prendergast (1859–1924) was an American painter who incorporated the feel of Art-Nouveau flatness, patterning, and arabesque into his

Central Park in 1903

Maurice Prendergast, 1903; oil; 20 3/4 x 27 in. (52.7 x 68.6 cm). The George A. Hearn Fund, The Metropolitan Museum of Art, New York.

This American painter incorporates the feel of Art-Nouveau flatness, patterning, and arabesque into his own style of Impressionism. Fashionable men and women stroll and ride in a tableau of urban park life; the rhythms of the repeated forms of horses and riders in the foreground and the carriages in the background serve as punctuation to this lively scene.

The Dressmaker

Edouard Vuillard, 1894, color lithograph,
9 3/4 x 6 3/8 in. (26 x 16 cm.). Abby Aldrich
Rockefeller Fund, The Museum of Modern Art, New York.
A woman is seen from the back as she leans over
her work; her neck, shoulders, and hair are lit by
the light that flows in the window and also illuminates
her workplace. Vuillard was greatly influenced by Japanese
prints, although this work, with its emphasis on light, also has
an Impressionist quality. The arabesques in the chairback and
the overall sense of flat patterning relate this work to Art Nouveau.

own style of Impressionism. Prendergast had spent time studying art in France before returning to settle in the United States. During his time abroad he wrote of his delight in the work of Vuillard and his enthusiasm for Japanese prints. Prendergast borrowed the Art-Nouveau preoccupation with surface patterning, and applied it to a more modern approach where exploration and exploitation surface is integral to the work of art.

It is fitting to end with the work of Pablo Picasso (1881–1973), the great Spanish painter, sculptor, graphic artist, and ceramist who worked in France, and who—more than any other individual artist—shaped the course of twentieth-century art. Picasso first came to Paris in 1900, and he flirted briefly with the linear arabesques and decorative flatness of the Art-Nouveau style, yet his rendering of form is also more plastic and solid than is typical. *The Blue Room, Picasso's Studio, Boulevard de Clichy* (1901), an early work of Picasso's Blue Period, signals his interest in the work of Toulouse-Lautrec by the painted reference to Lautrec's poster of *May Milton* dancing, which hangs on the wall above the unmade bed. The nude bather in Picasso's painting is not a *femme fatale*, but rather one of the many images in which Picasso explores his own varied and personal response to his female subjects.

Painting that is about painting, art that is about art—these became the defining principles and preoccupations of twentieth-century style in painting, sculpture, and the applied arts—replacing Art-Nouveau ideas of art being subordinate to a decorative unity. In architecture, principles of Art-Nouveau decoration were replaced by the simplicity of functionalism. Truely, a new age had begun.

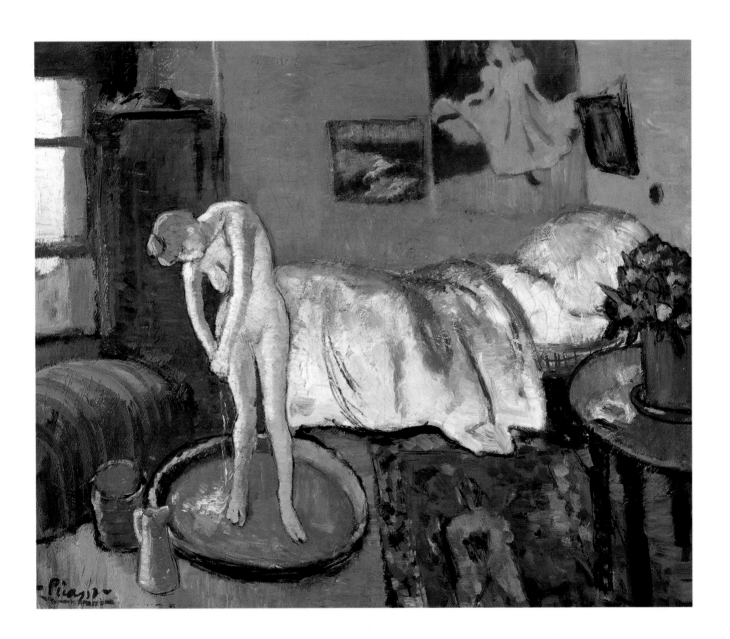

The Blue Room, Picasso's Studio, Boulevard de Clichy

Pablo Picasso, 1901; oil on canvas; 20 x 24 in. (50.6 x 61.6 cm). The Phillips Collection, Washington, D.C.

Picasso flirted briefly with the linear arabesques and decorative flatness of the

Art-Nouveau style, yet his rendering of form is also more plastic and solid than is typical.

His interest in the work of Toulouse-Lautrec is evident in the painted reference

to Lautrec's poster of May Milton dancing, which hangs on the wall above the bed.

**The Scottish
Musical Review**

*Charles Rennie Mackintosh,
1896; poster; 92 x 38 in.
(233.7 x 96.5cm).
The Museum of
Modern Art, New York.*
Mackintosh's poster
shows the angularity
and geometry that
distinguished the Glasgow
style in poster art from
its French counterparts,
such as Toulouse-Lautrec.
An elongated, possibly
winged figure is framed
by an abstract halo and
supports birds and abstract
flowers. The ambiguous
subject of this decorative,
linear design is typical
of the Glasgow artists.

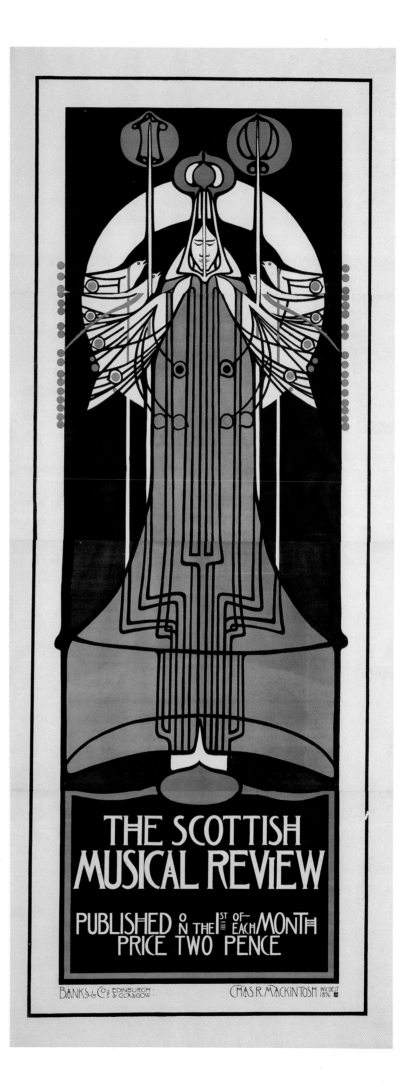

The Harvest Moon

Charles Rennie Mackintosh, 1892; watercolor on paper;
138 9/16 x 108 11/16 in. (352 x 276 cm). Glasgow School of Art, Glasgow.
Mackintosh was known as a watercolorist as well as an architect
and designer. *Harvest Moon* gives an idea of the mystery and
lyricism that characterized the Glasgow style, and the connection
to the land of faerie that was part of its inspiration.

Poster for the First Phalanx Exhibition

Wassily Kandinsky, 1901; color lithograph; 18 x 23 1/4 in. (52 x 67 cm). Guggenheim Museum, New York.
Charging soldiers in battle helmets point their spears and shields as they race toward the
enemy in this German exhibition poster. The scene, with tents and a castle in the background,
is framed by columns and set in an ornamental frame that incorporates the poster's lettering.
Forms are rounded and flattened almost to the point of dissolving into abstract pattern.

Farewell

Wassily Kandinsky, 1903; color woodcut; 12 1/16 x 11 1/2 in. (30.7 x 29.8 cm).

Städtische Galerie im Lenbachhaus, Munich.

The flat, decorative linear style and subdued color of Kandinsky's romantic woodcuts are
based on medieval fairy tales. This Russian artist fell under the influence of Art Nouveau while
he was living and working in Germany. Here, a knight in armor, ready to joust, stands by his
horse, lance in hand, while an elegant lady leans on his shoulder in the sadness of parting.

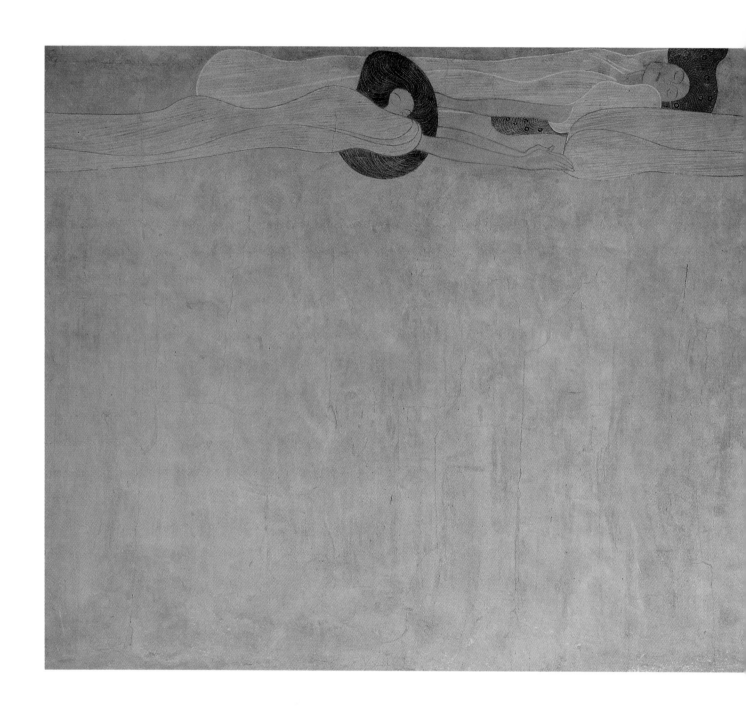

The Beethoven Frieze

Gustave Klimt, 1902; detail. Oesterreichische Galerie, Vienna.

Klimt created the Beethoven Frieze for the 1902 exhibition of the Vienna Artists' "Secession."

Shown here is a detail entitled "The Longing for Happiness Finds Satisfaction in Art."

Longing is personified by the mystical female figures floating over the woman playing the harp.

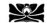

Salome (Judith)

Gustav Klimt, 1909; oil on canvas;
70 1/8 x 18 1/8 in. (178 x 46 cm).
Galleria d'Arte Moderna, Venice.
Klimt's *Salome* is a bare-breasted
femme fatale who holds the severed
head of John the Baptist in her claw-
like hands. Klimt treats this popular
Art-Nouveau subject in a typically
elegant fashion, with curving lines
and flat geometric patterning. Salome's
gaze seems drugged and unseeing
as she gloats over the grizzly reward
she has received for her dance.

Religious Calendar

Koloman Moser, 1898;
lithograph; 37 3/8 x 24 5/8 in.
(94.9 x 62.5 cm).
The Museum of Modern
Art, New York.
This Austrian artist's
flattened, elegantly linear
style is a good example
of later Art Nouveau.
A hooded figure is seen
in profile holding an hour-
glass; her face is framed by
a few twining strands of hair
and a bunch of flowers so
abstracted they appear to be
a cluster of simple circles.

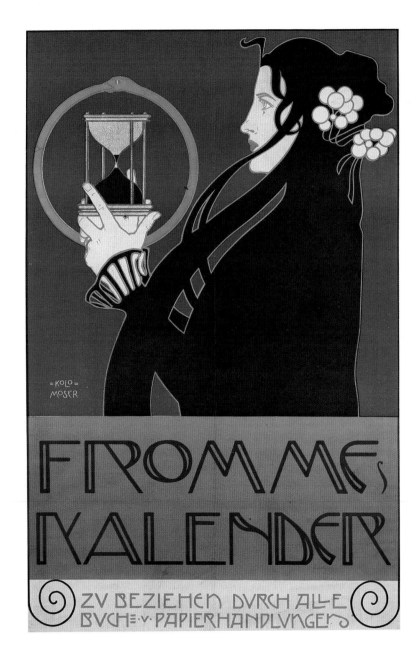

The Seamstress

Edouard Vuillard, c. 1893; color lithograph, wood engraving, and woodcut.

Elisha Whittelsey Fund, 1973, The Metropolitan Museum of Art, New York.

The model for this work was Vuillard's mother, who was a seamstress by
profession. A modest figure bent over her work, she sits while a pile of
fabric forms an undulating wave around her. The windows, door, and wall-
paper of the background are reduced to simple flat patterns, and Vuillard
has here combined the principles of Japanese art and Art-Nouveau line.

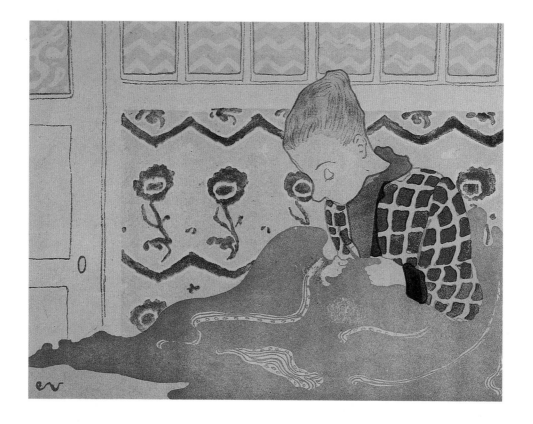

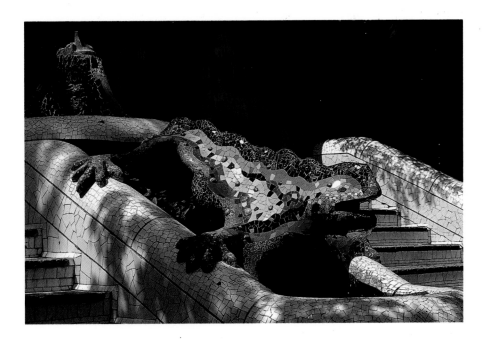

Creature from the Entrance Pavilion of the Park Güell

Antonio Gaudí, 1900–14, Barcelona.

One of the many fanciful creatures adorning the pavilion of the Park Güell in Barcelona,
inspired by Gaudí's fanciful imagination and unparalleled genius with materials.

Following page:
Front Facade of the Casa Milá

Antonio Gaudí, 1905–10, Barcelona.

The front of this apartment building is unified by its
curving irregularity—with hardly a straight line in sight. This
style is present not only in the facade and roofline but through-
out the entire building—in its floor plan, and every aspect
of the decoration, including the seaweed-like iron railings.

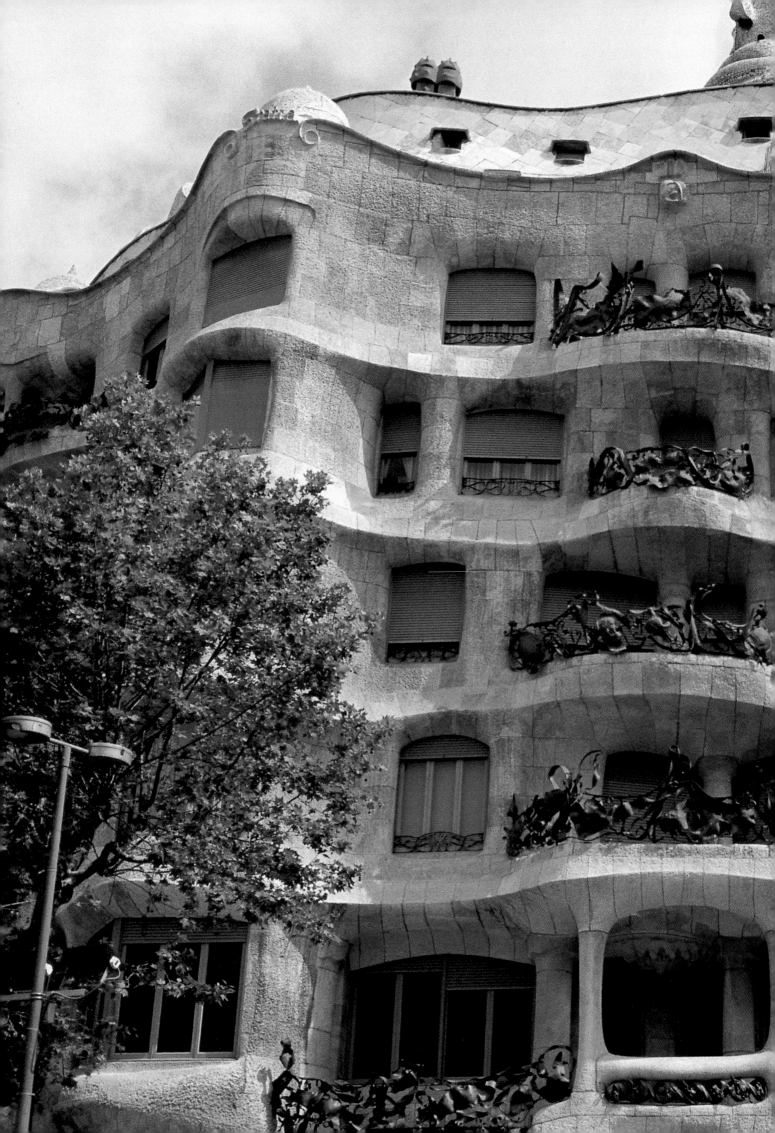

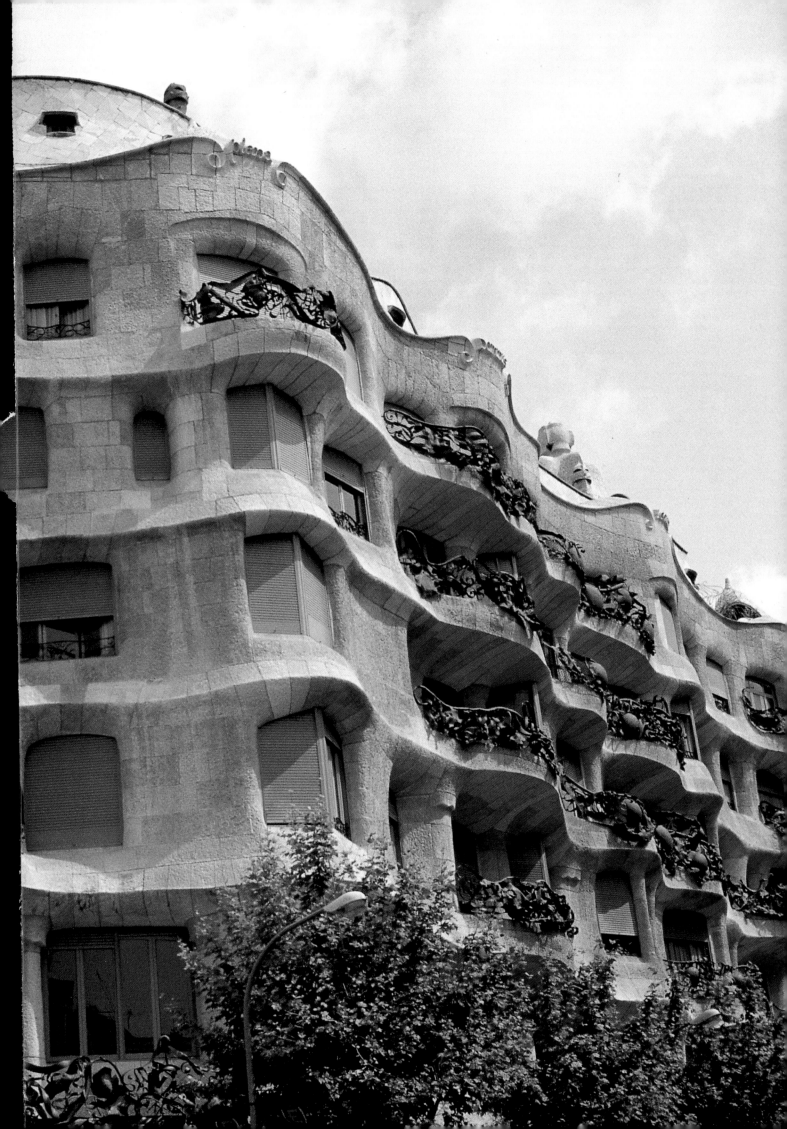

INDEX